CW00470685

HEADBANGERS

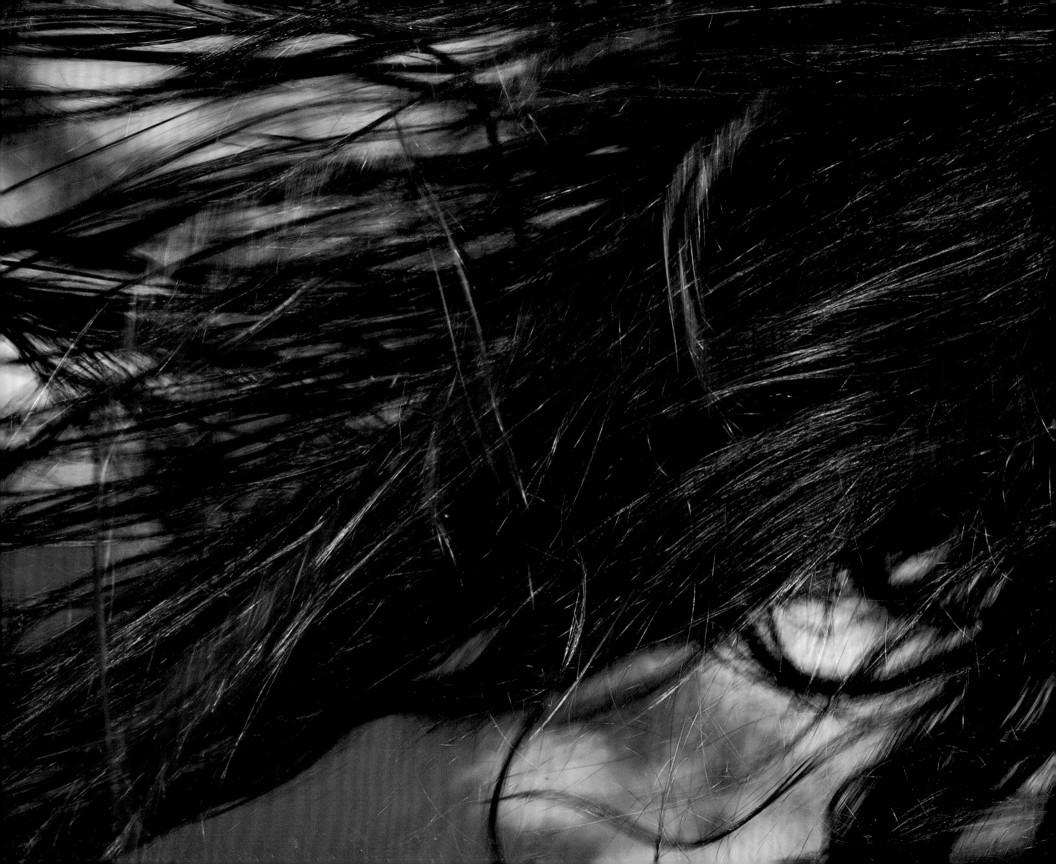

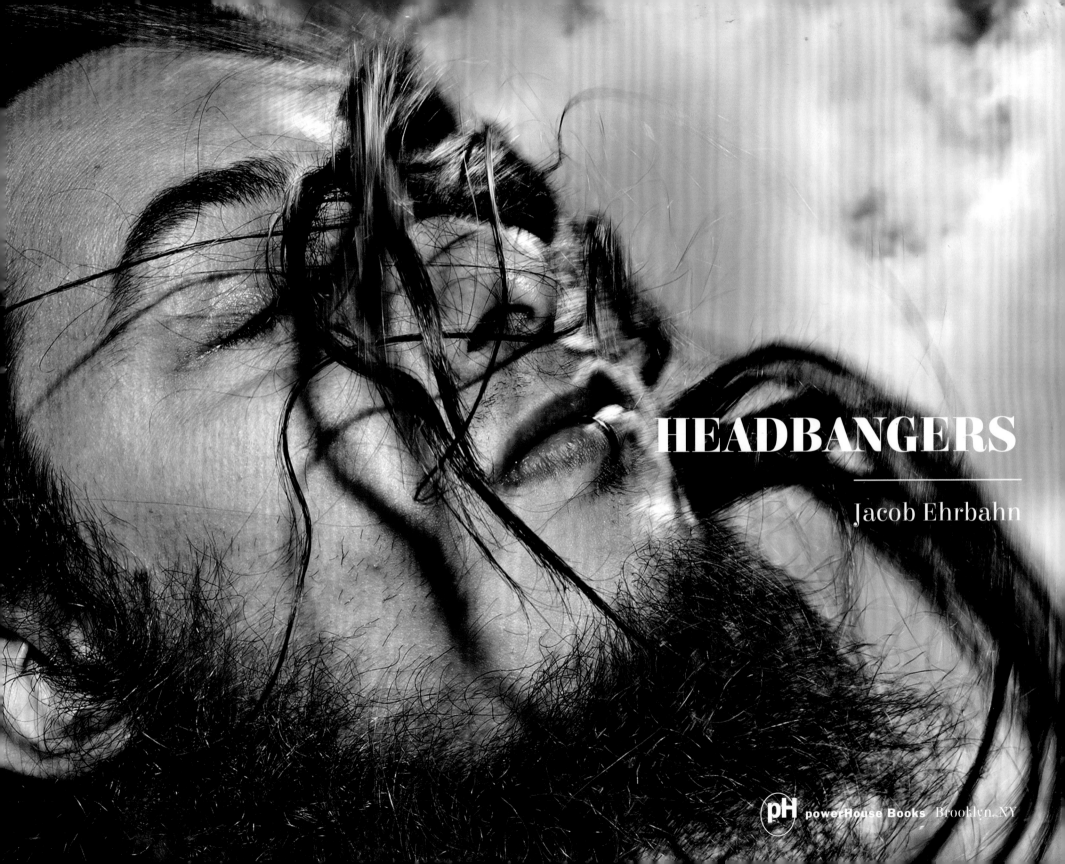

HEADBANGERS

Jacob Ehrbahn

powerHouse Books Brooklyn, NY

The 67 photographs in this book are edited down
from approximately 14,000 exposures shot in the
summer of 2012 and 2013 at COPENHELL, the
largest Danish metal festival, WACKEN OPEN AIR
in Germany, and the Swedish festival METALTOWN.
They are all shot during concerts.

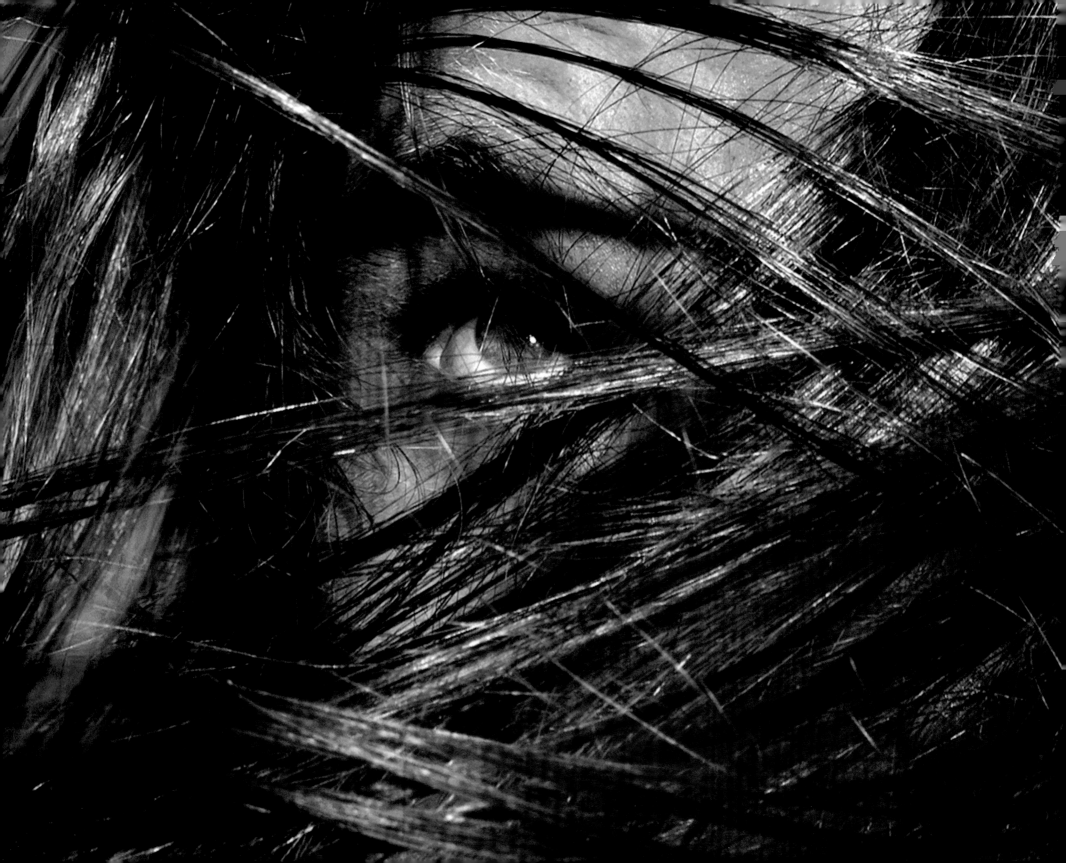

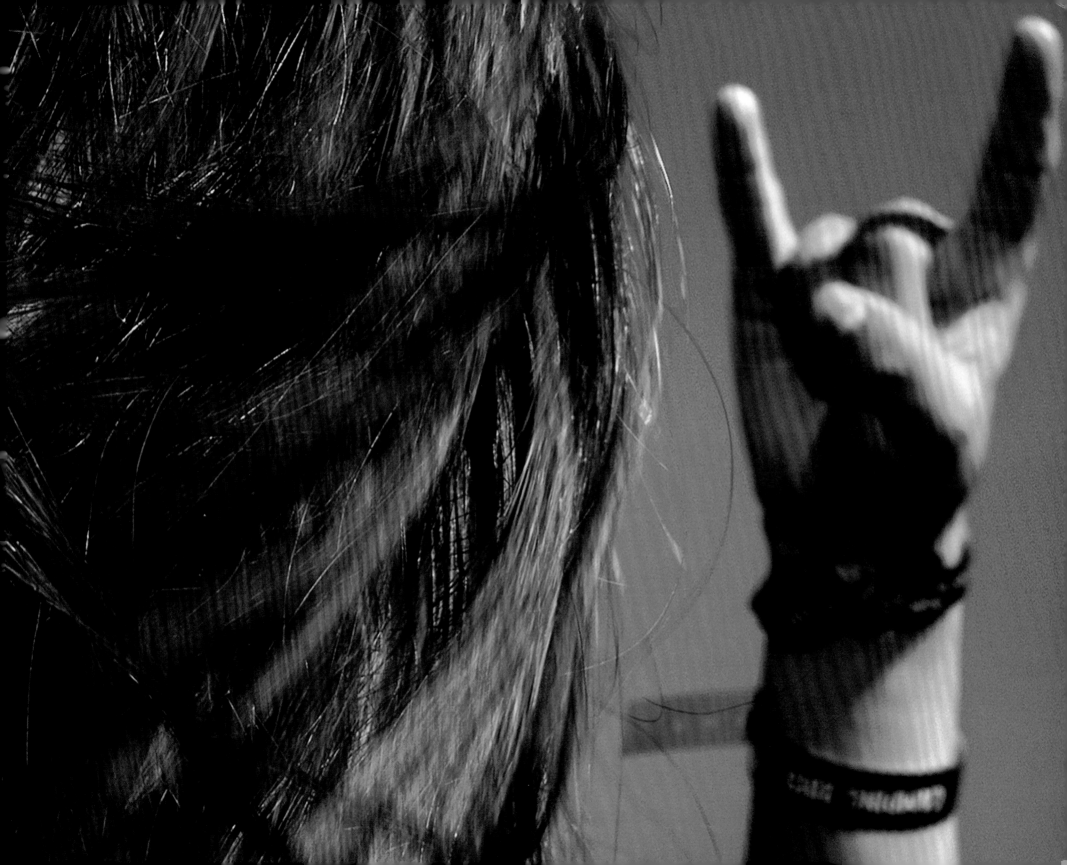

THE BEAUTY OF ABANDON

Photography is an advanced form of lying. Even in after-dinner speeches, when we celebrate the importance of authentic and immediate photography, doubt often descends on the rostrum. This doubt must always be present, for we know there is no objective truth and no objective photography. Photography is and remains a personal expression; equal parts observation and self-portrait. And sometimes the pendulum swings strongly in one direction or the other.

The photographer cannot be a photographer without manipulating his medium or the objects and people in front of the viewfinder. A choice has to be made. This is nothing new. Without it few pictures would be taken. However, the photographer is not always the sole manipulator. The subjects of the photograph often manipulate the photographer, consciously or unconsciously. So when we say that a photograph always has an originator, and that there is intention and thought behind the image, we should also consider the risk that the photographer will be manipulated — voluntarily or involuntarily. Therefore, when we look at the resulting image, we sometimes must question what we see — is it the reality of the frame, or a frame of reality?

There are, however, exceptions to the golden rule. There are places, persons and instances that don't match this theory of manipulation, dissimulation, and cynical intentions.

One of these exceptions is Jacob Ehrbahn's photographs of headbangers.

This thing we choose to call life is made up of various compartments and states of being. Some are connected, others are islands unto themselves. The common denominator is that rules of behavior exist in every compartment. Rules for relating to the people around us. Rarely can we do just as we please. And if we wanted to, we probably wouldn't dare for fear of reprisals, exclusion, or embarrassment. Perhaps even for fear of provoking this feeling of embarrassment in others. On our own behalf, that is. We wrap ourselves in common sets of rules, which we fundamentally accept. It makes our interaction easier. The compartments fulfill a variety of needs, and our ability to step in and out of them — to satisfy our often conflicting needs — creates the opportunity to be more than just one person.

We rarely express emotions loudly and visibly. If we do, some might say: "He wears his heart on his sleeve." Which is seldom intended as a compliment.

No, we keep emotions to ourselves or share them with those nearest and dearest: our children, the man or woman in our life, our closest friends.

However, in certain compartments it is not only accepted, but also desirable that we show our emotions. In the world of sports it is legitimate to show excitement or grief. We can cheer as loudly as we want, and the most dedicated fan can shed a tear when his team loses the game.

Sports is not the only place, though, where circumstances encourage the free flow of emotions.

Jacob Ehrbahn has found such a place. In *Headbangers*, the raw and unadulterated feelings of freedom and abandon, euphoria and joy, hit us directly in the face. This is heavy metal fans at full throttle; it's life-affirming and beautiful.

Each photograph is a distillation that gives us access to what appears to be a private universe. It only appears to be, for the abandon expressed by the individual head-banger does not happen in an enclosed space, but rather in a large open space where people let loose side by side. They are together and they are alone. Or alone and together. No, not alone — that could be confused with loneliness, and that is not what's happening here. They are united, part of something larger than themselves.

In a split second the photos capture the beauty of abandon. A state so difficult to capture in a photograph that it is rarely seen. And when it is not abandon, it is an uninhibited explosion of energy, rage, enthusiasm, or just pure musical fury.

These are very personal photos, because their direct nature never spoils the sense of intimacy and of being present in the moment. *Headbangers* is unfiltered photography. It doesn't get more direct than this. These are portraits, but without the black or white backdrop and the smiles at the photographer. This is reportage and documentation without a safety net. As such, the series is a natural extension of a classical tradition. A

tradition that — with the photograph as evidence — seeks to tell a story about an event and how it affects the participants.

Why do thousands of young people whip their heads back and forth and up and down? Jacob Ehrbahn's photos are a journey of exploration into human nature and behavior. Knowledge is the goal, stubbornness is the method, and hard work paves the road to completion — coupled with a unwavering belief that the great photo is out there somewhere. If the substance is present, that is, and if one keeps seeing and photographing for as long as it takes.

Per Folkver, November 2013

"It's energy that has to be released. It's all the pent-up energy and anger that has to be released all at once. It's liberating."

—**Tobias,** young festival-goer at Copenhell 2012

"It's the ecstasy that hits you – the fury in the music that becomes one with your body. Metal music is extreme, and the movements you make have to be, too. It's not just a bit of head-bopping – the whole body has to be part of it. It's the inner monster."

—**Villads,** young festival-goer at Copenhell 2012

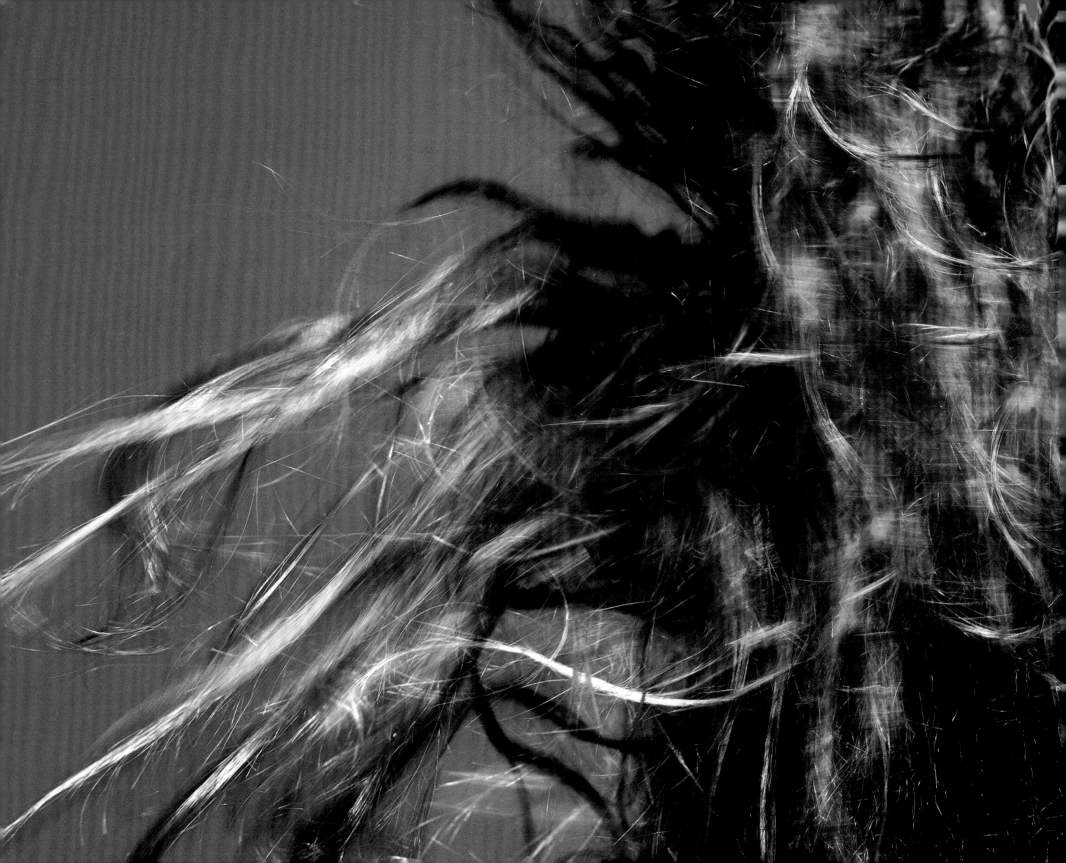

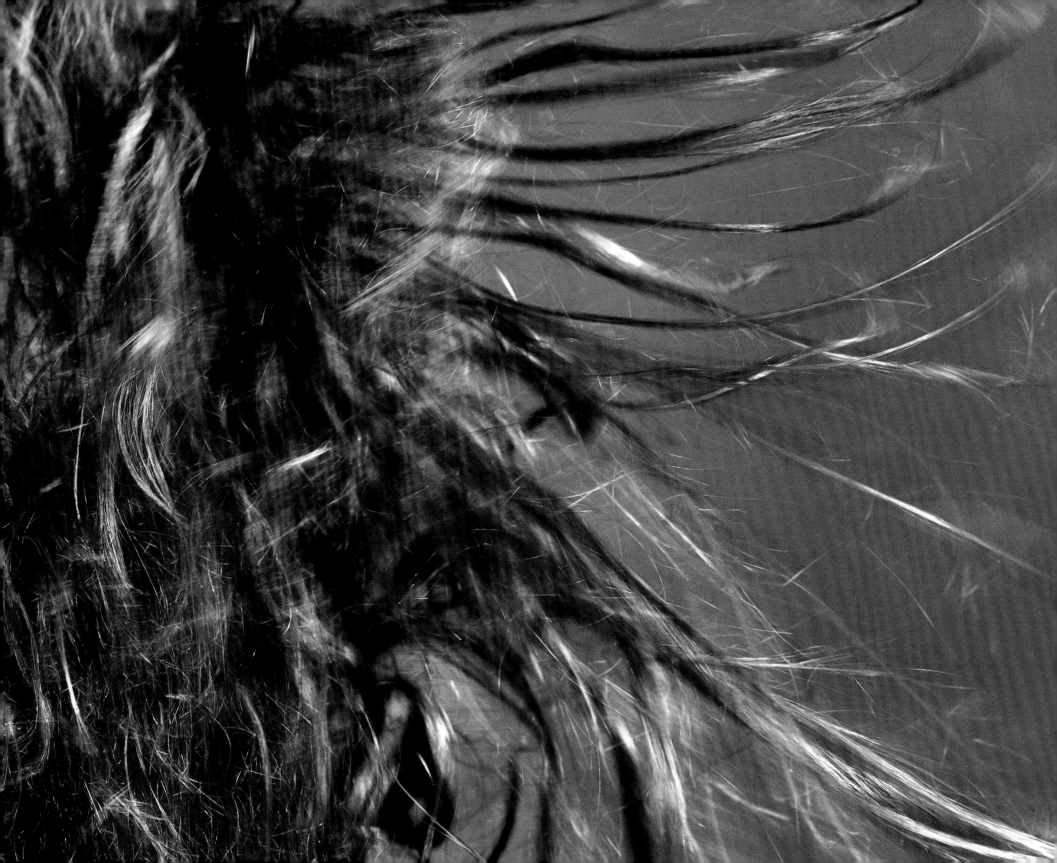

STYLES OF HEADBANGING

Headbanging is a special dance form that encompasses violent shaking of the head in rhythm to music. One "bangs" one's head back and forth or around so that one's hair wildly follows in correlation to the rhythm. This form is most common for rock music and heavy metal.

There are various styles of headbanging, including:

The Up and Down - Shaking the head up and down. This style is a classic that epitomizes headbanging.

The Circular Swing - Swinging the head in a circular motion. This style is also commonly known as the Windmill or Helicopter.

The Half-Circle - Swinging the head repeatedly from side to side in a downward arc.

The Figure Eight - Shaking the head in a figure eight motion.

The Side to Side - Shaking the head from side to side, whipping the hair on each transition.

The Whiplash - An especially violent form of the traditional Up and Down style, characterized by the hair of the headbanger moving about so rapidly that it obscures their face.

The Full Body - Also known as the "Body Bang." A full-blown assault of headbanging. The practitioners will start with a classic Up and Down and when the tempo starts to get aggressive, they wil throw their head down to their knees and bring it back up to an Up and Down.

The Drunk Style - Practiced by banging your head in random directions at your own pace, while stomping around out of balance. This style is not beat-driven, it is more often booze-driven.

The Tandem - This form of headbanging is practiced by two people, you stand side by side and headbang in unison.

Technique

Various styles are often mixed together according to taste and to the tempo and aggression of the music. Headbangers' bodies usually move in unison with the head, reducing the strain on the neck and making the body move in a serpentine, up-and-down fashion to the music. You will often find headbangers standing with the legs slightly bent and the hands on the knees or thighs while they are performing the Half-Circle or other styles, as it allows maximum movement and balance.

Health issues

The violent movements may have health consequences, such as neck pain, headaches, and shoulder problems. Even cases of whiplash have been registered. Further unsafe practices, such as headbanging drunk or too close to someone else, often cause injury.

Wikipedia contributors, "Headbanging," *Wikipedia, The Free Encyclopedia*, 2012

"When I headbang, I not only hear the music, I feel it throughout my body. There's a certain sense of community that we metalheads share. The mood, the setting, the vibes are beyond description. You let your movements become one with the music. It looks really cool and feels wicked. All thoughts of everyday problems are channeled somewhere else. You go berserk and forget everything."

—Tobias Lønstrup Nørholm, young festival-goer at Copenhell 2012

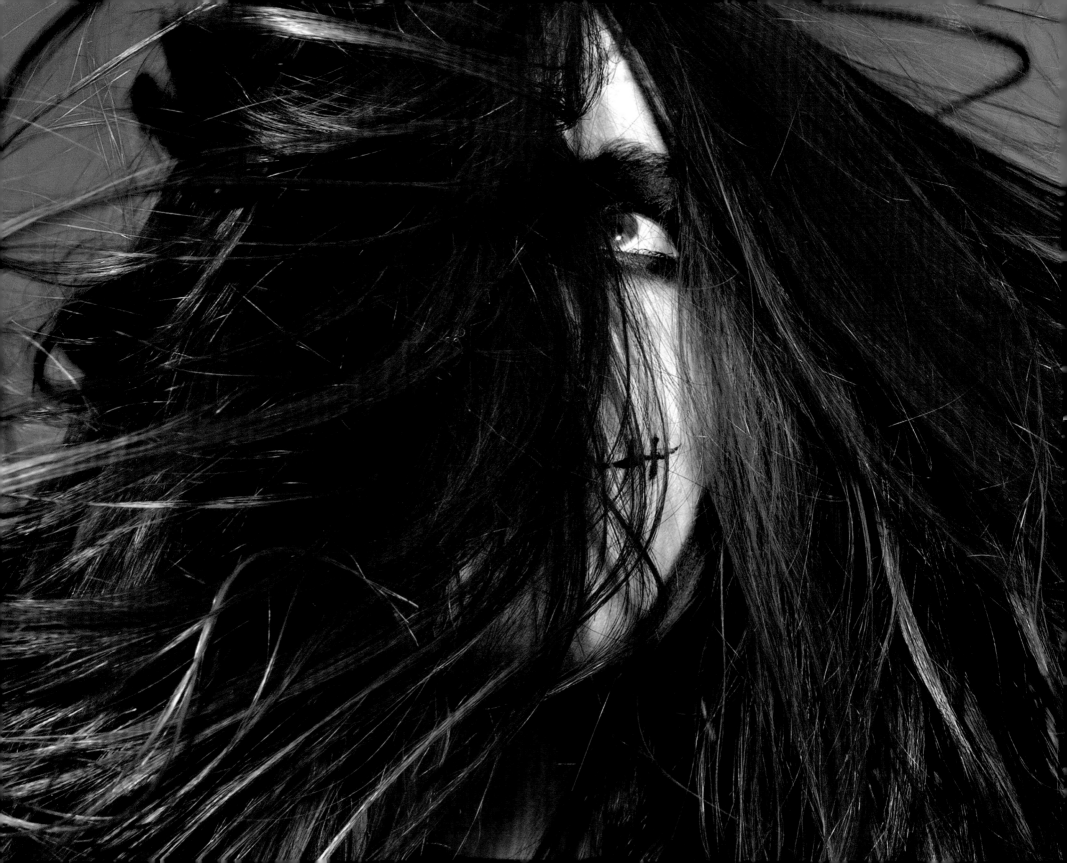

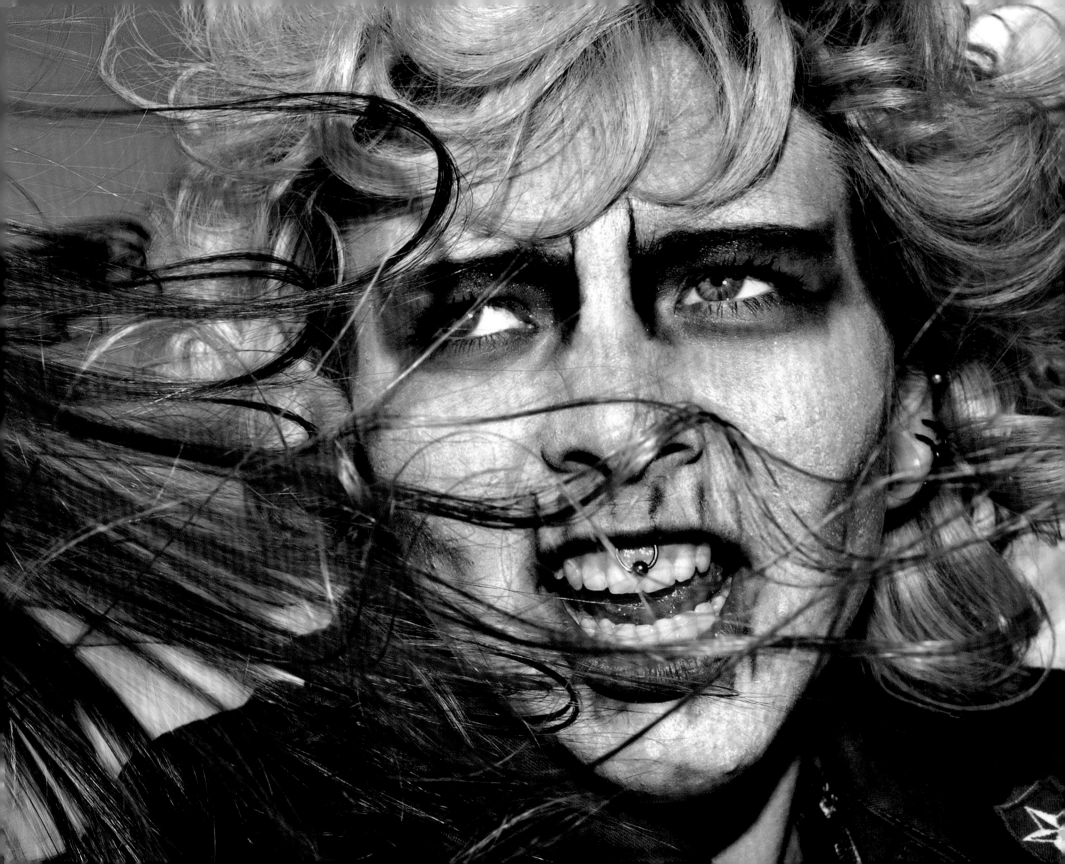

FOR THOSE ABOUT TO ROCK...

Growing up in a Copenhagen suburb, I never heard heavy metal played on the radio. It was a genre of music most people loved to hate. It was savage and maladjusted, and perhaps that's why it appealed to me. At 13 I attended my first heavy metal concert with a group of friends. On December 9, 1983, Scorpions visited Copenhagen on their Blackout Tour, and we arrived early to get a place in the front row. The band had been playing for ten minutes when security guards lifted all of us over the guard rail, and we had to watch the rest of the show from seats further back in the hall. Still, it was pure magic to experience the music and the atmosphere live, and this was my first in a long series of heavy metal concerts with endless guitar and drum solos, burning guitars, papier maché monsters, costumed musicians, and fire, fire, fire. A new universe had been revealed and we loved everything about it, despite the butterflies in our stomachs at these concerts. It was transgressive to be among the youngest in an audience made up of long-haired men wearing band patches all over their clothes and rivet belts.

Since those early-80s experiences with Scorpions, Judas Priest, DIO, AC/DC, Mötley Crüe, and other great bands, my taste in music has evolved in many other directions. Standing at the entrance to Copenhell, Denmark's largest metal festival, 29 years after my first concert, I was well aware that the music had gotten faster and harder and had been divided into an untold number of subgenres such as thrash metal, death metal, black metal, metalcore, viking/folk metal, melodic death metal, progressive metal, power metal, and deathcore, just to name a few. I had no sense of the culture of the contemporary audience, except for the fact that much of the music appealed to a very tough crowd. I had no set idea about what to photograph, I only knew that the photos had to capture the ferocity of the music, and that I had to get up close and personal. Really close. The butterflies in my stomach were not unlike those I felt as a young heavy metal fan going to concerts in Copenhagen.

On the very first day of Copenhell I fell in love with you. It was glaringly obvious that I wanted to be with you headbangers, and fortunately the feeling was mutual. When I stepped into your private space without warning, when I fired my flash in your faces from all possible and impossible angles, you let down all your guards and let me photograph. You cast vanity overboard and allowed me to get close as you surrendered to the music. I met you in the front row where you were crammed together like fish in a barrel, while I was safe beyond the guard rail. I met you in the mosh pit and thrashed around with you, and I sought you out at the back of the crowd where you could drink a draft beer without spilling. No matter where I found you, be it in Denmark, Sweden, or Germany, I was always met with cooperation and an understanding of what I was doing.

My encounter with the world of metal of 2012-13 has been uniformly positive. I sometimes felt I had stepped into a time warp, experiencing bands like Accept, Twisted Sister, Scorpions, and Iron Maiden playing the same hits they performed 25 years ago. It has also been fascinating to enter a world in which the esthetics are more or less the same as back then: Cropped denim jackets, stitched-on band patches, rivet belts and arm bands, band t-shirts and long hair.

Much to my surprise, I felt more in synch with the energy of the heavier, wilder, faster, and harder music of today than with the bands I knew from the 80s. But then again, the music was never the most important thing to me in this project. I was fascinated by you headbangers and your sense of complete abandon. Your vulnerability combined with ferocity, your ability to take off on interior journeys while remaining part of a community. I was fascinated by all the moods the music provoked in you, the little moments of peacefulness, anger, joy, concentration, and redemption.

Thank you for letting me get close.

Jacob Ehrbahn, December 2014

"Everything becomes one when the music, the audience and the band move to the same rhythm. You just can't help it, you're swept away by the feeling. And it's really cool to show the band that you like their shit. You can worry about the pain the next day."

—Karina, young festival-goer at Copenhell 2012

"When I headbang, I feel like I'm giving something back to the band that they have given me through their music."

—Stine, young festival-goer at Copenhell 2012

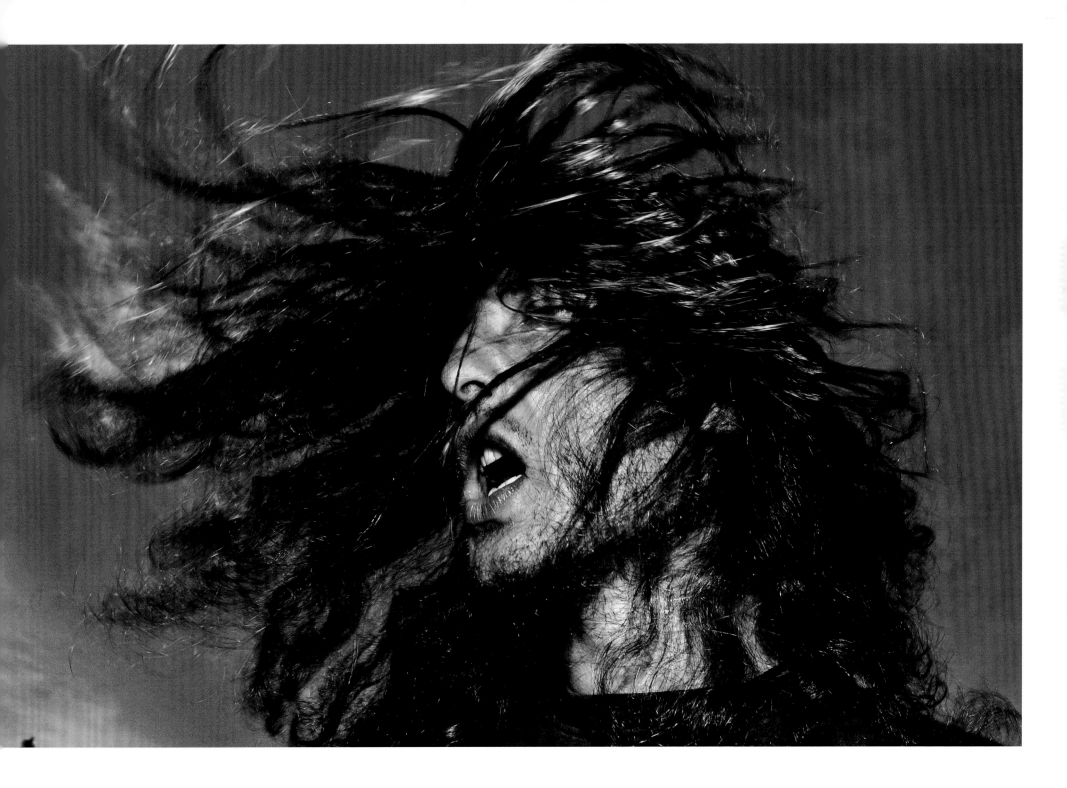

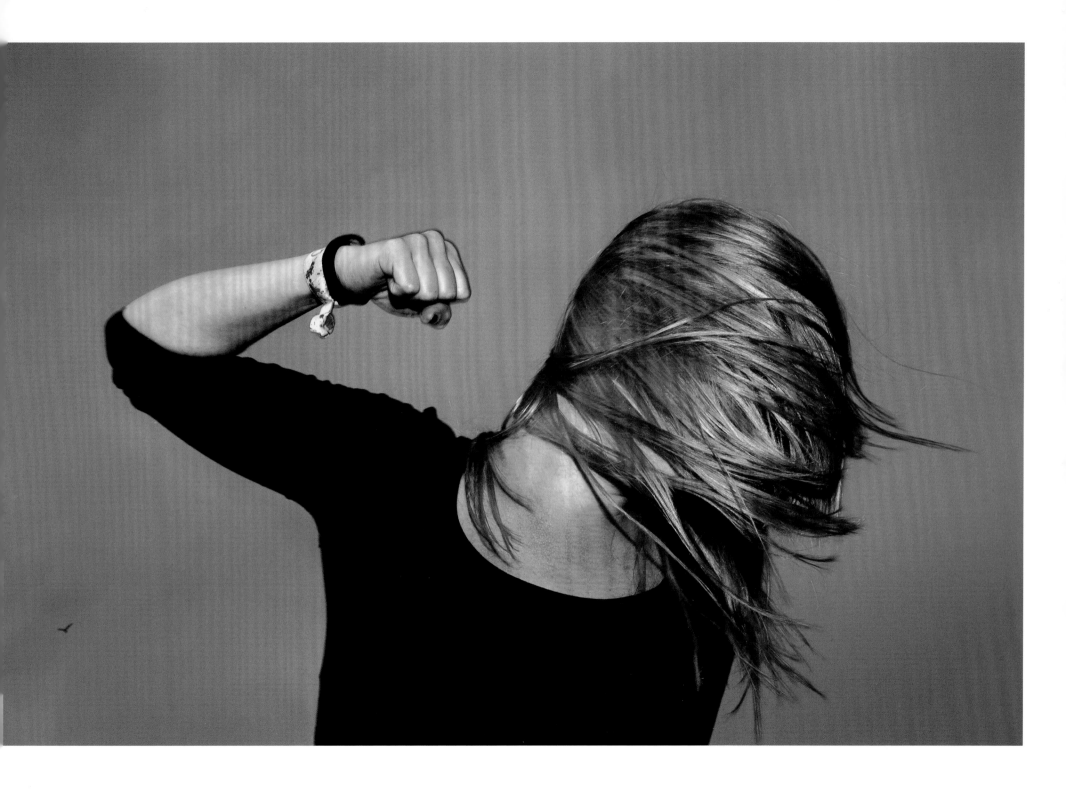

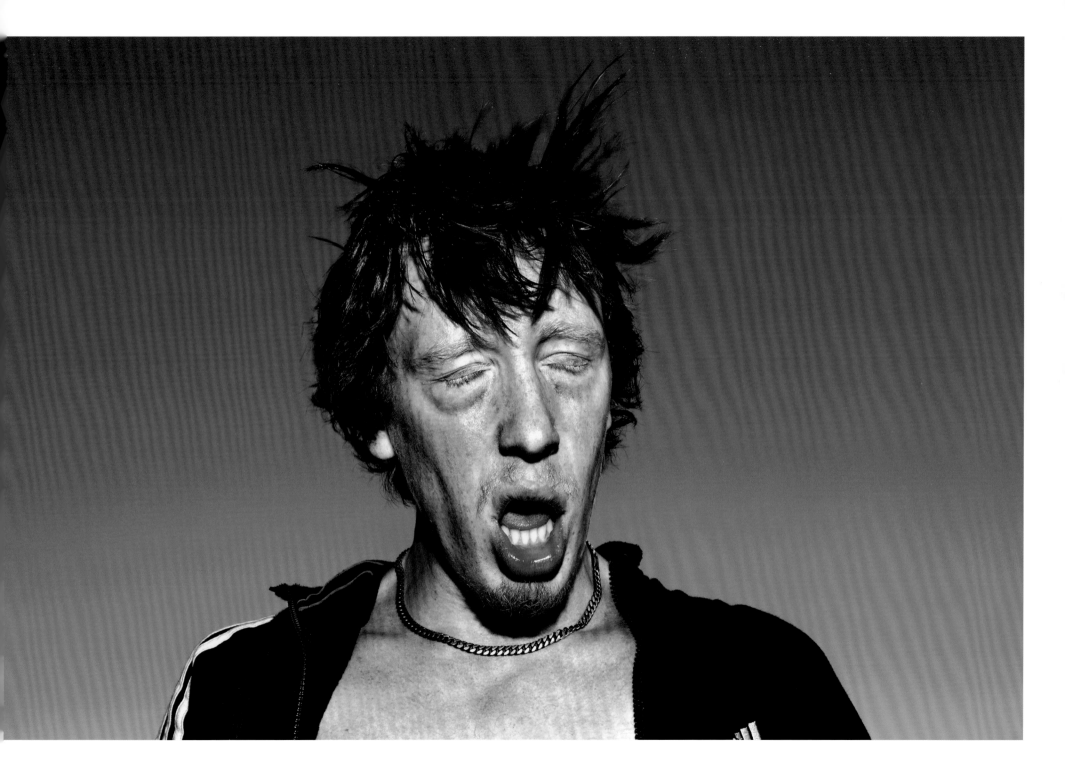

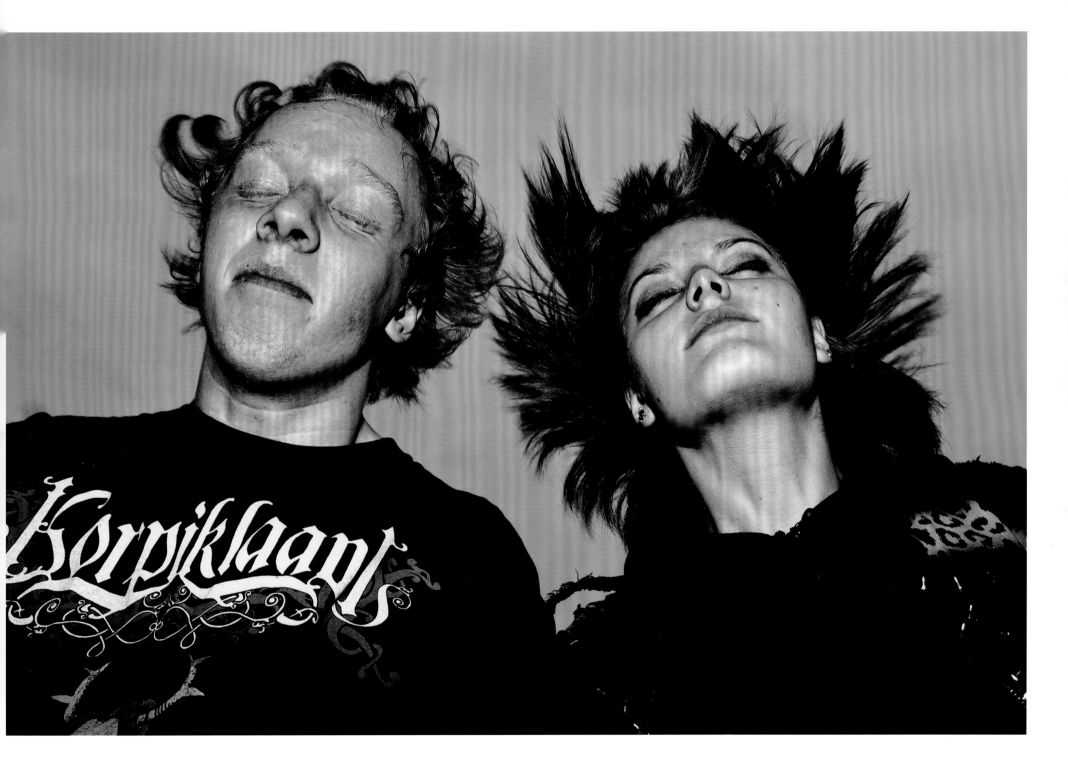

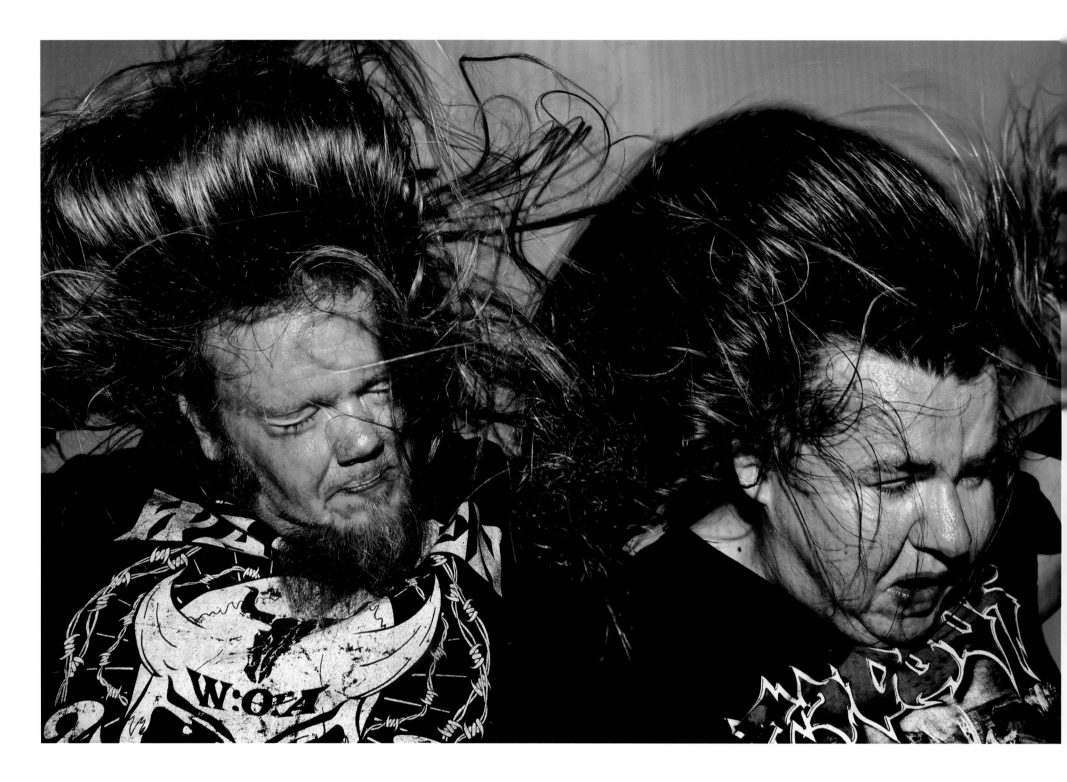

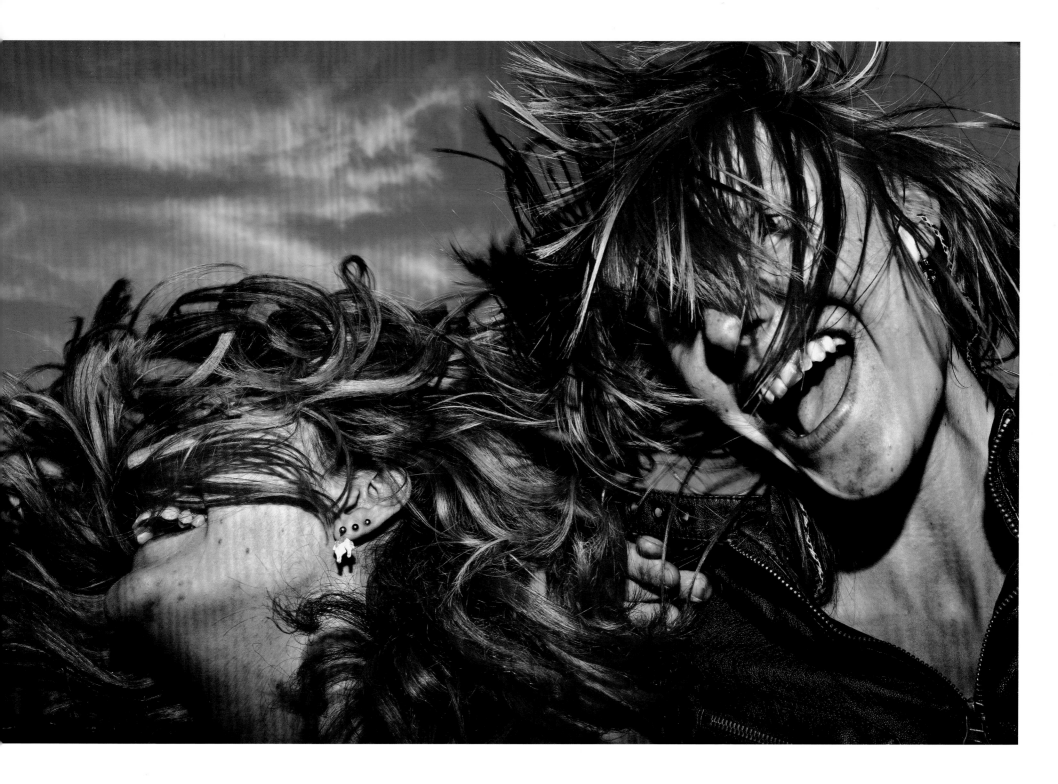

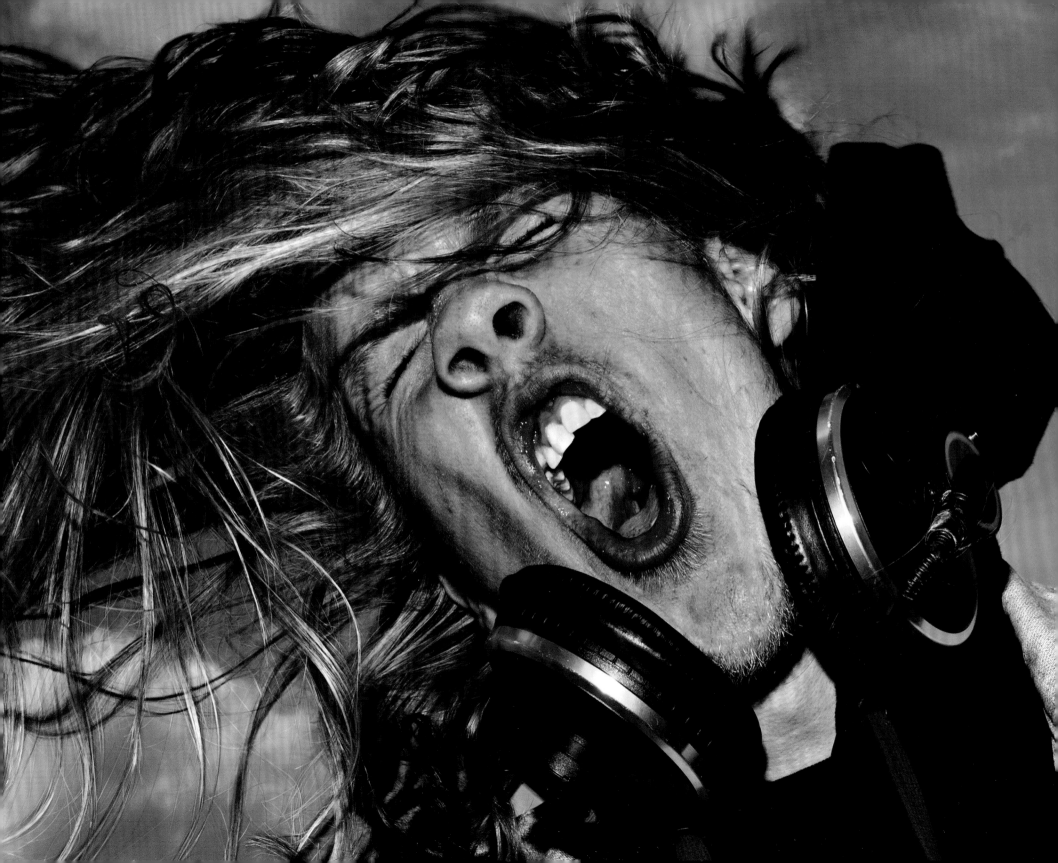

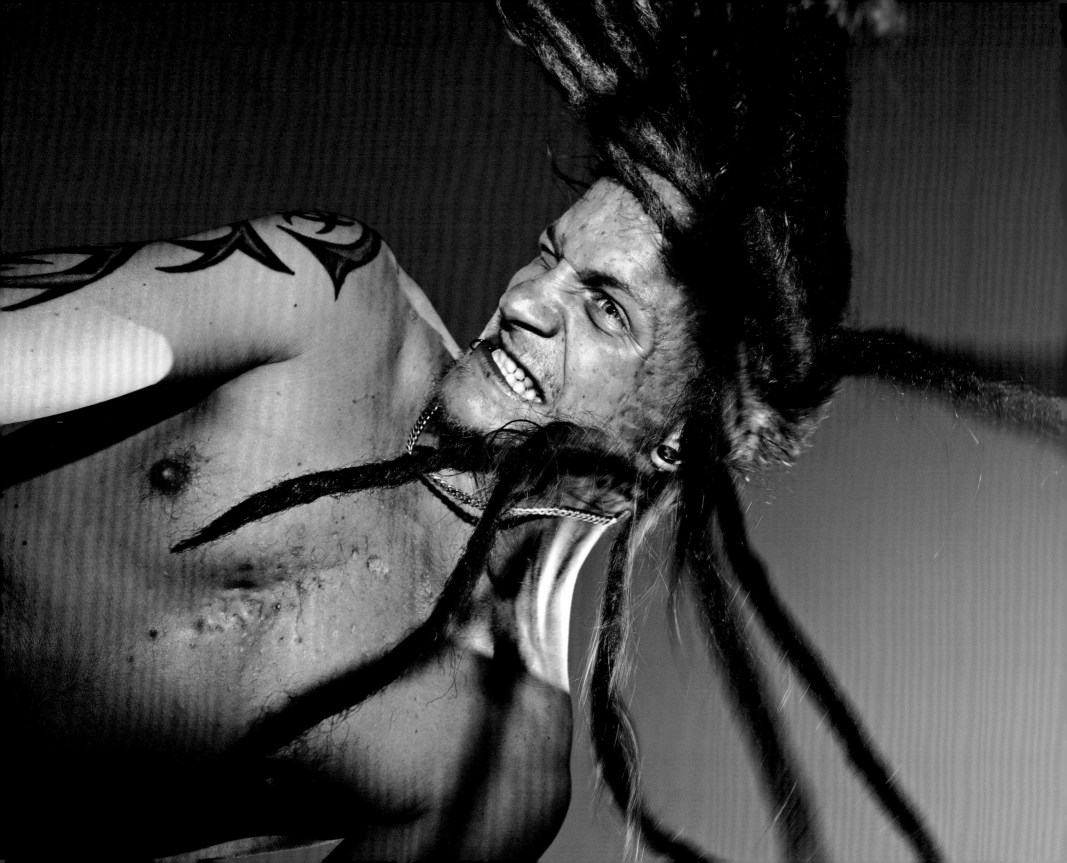

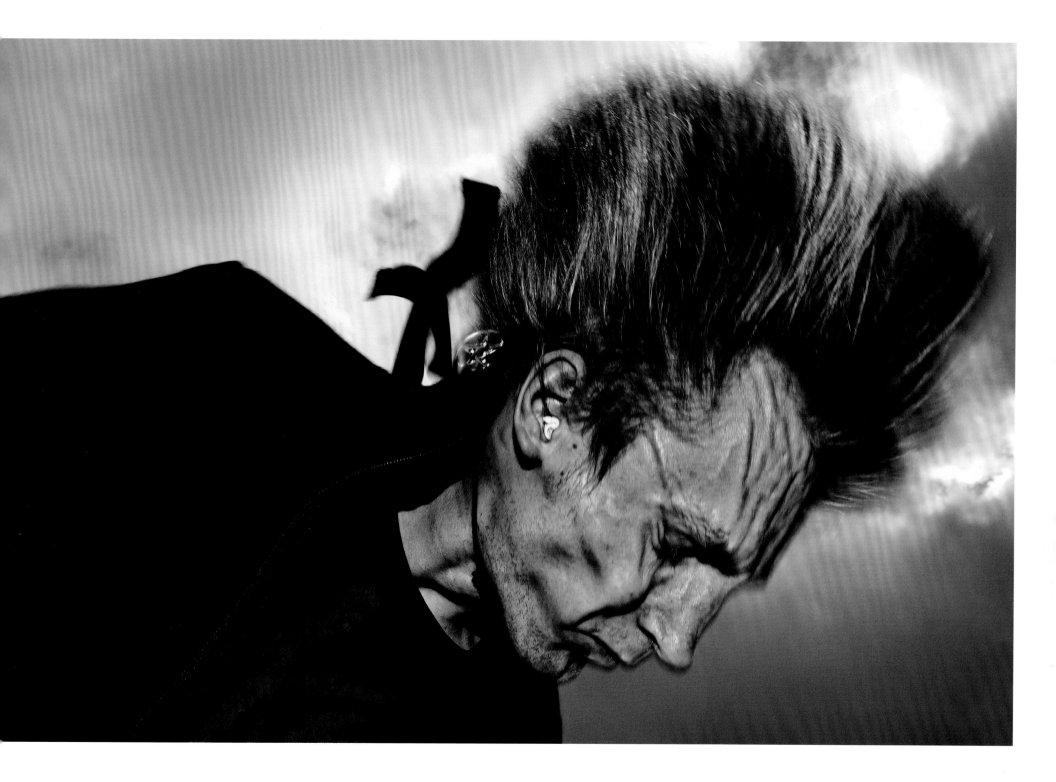

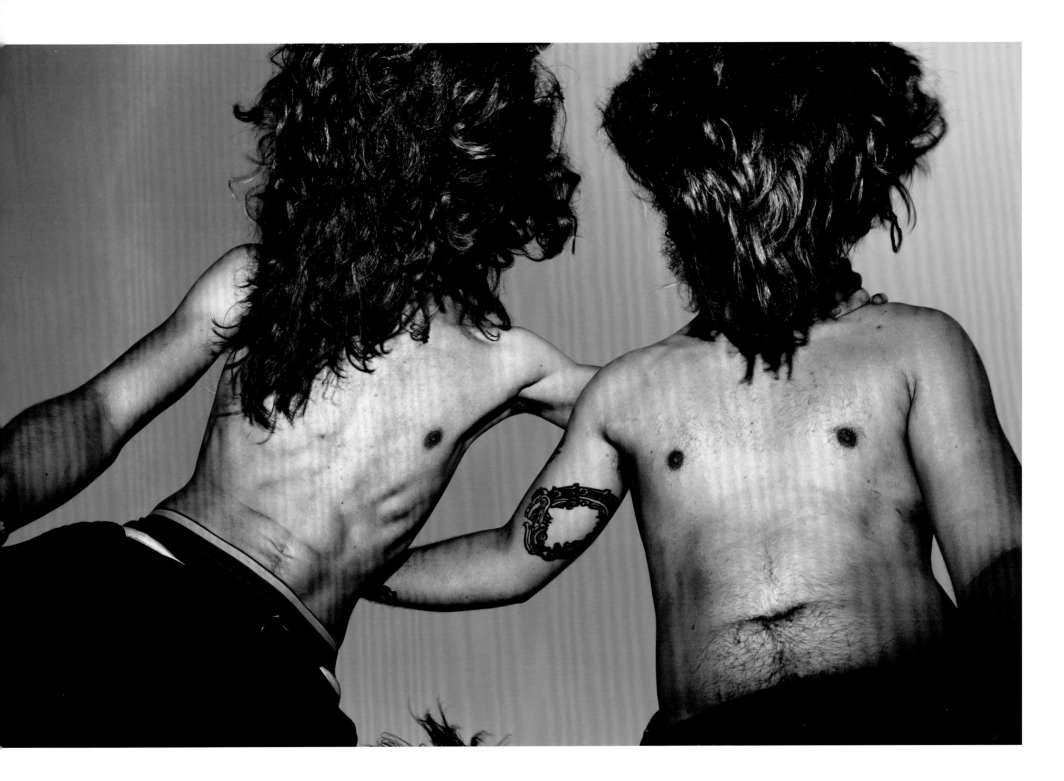

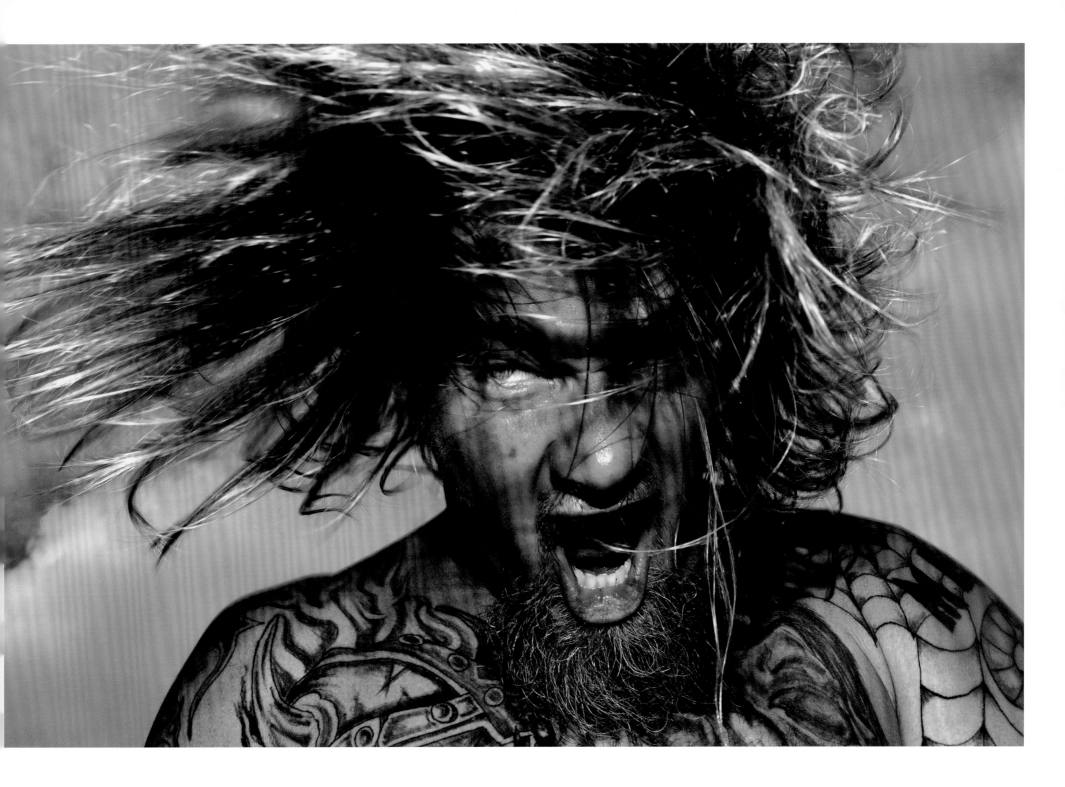

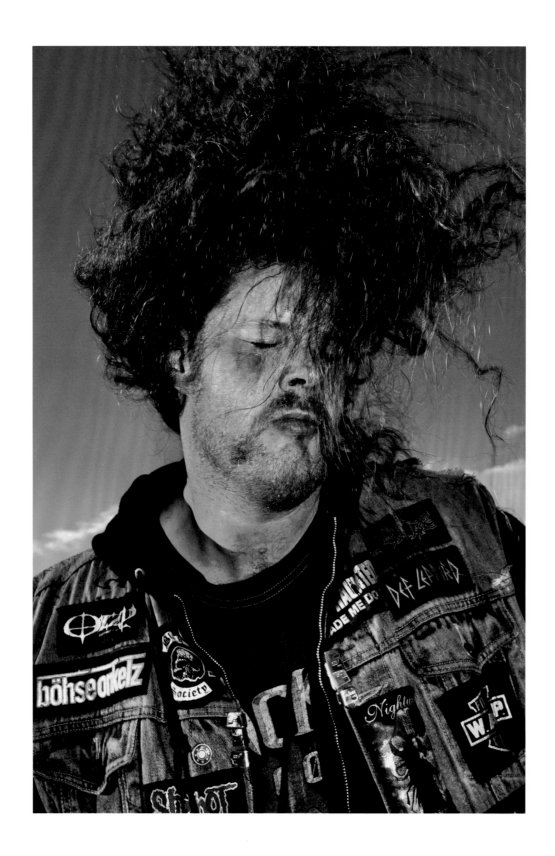

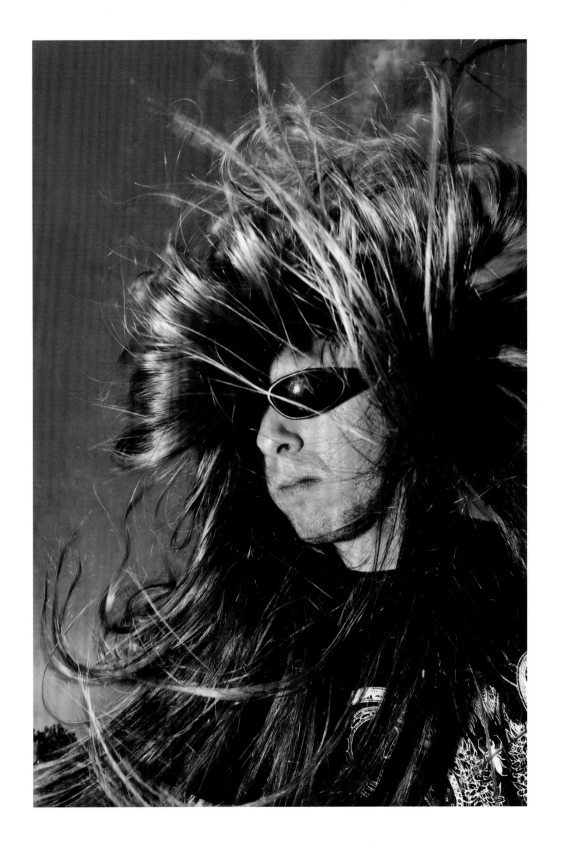

40

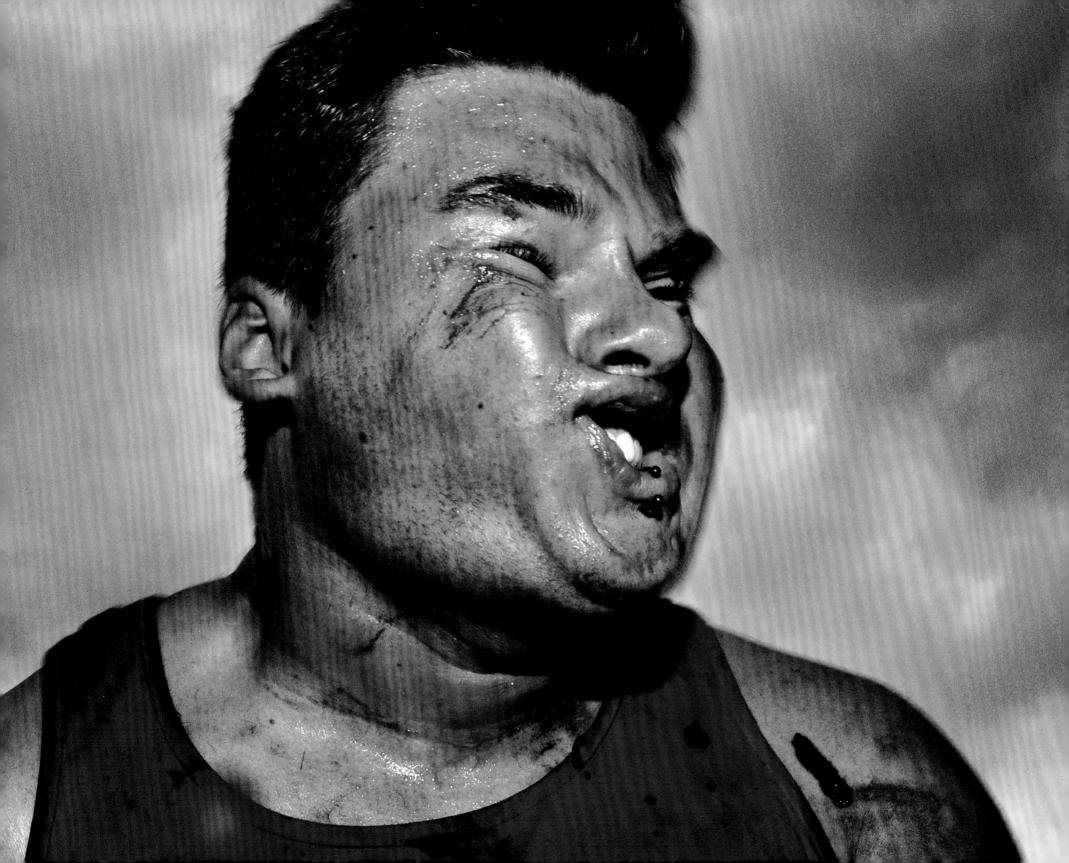

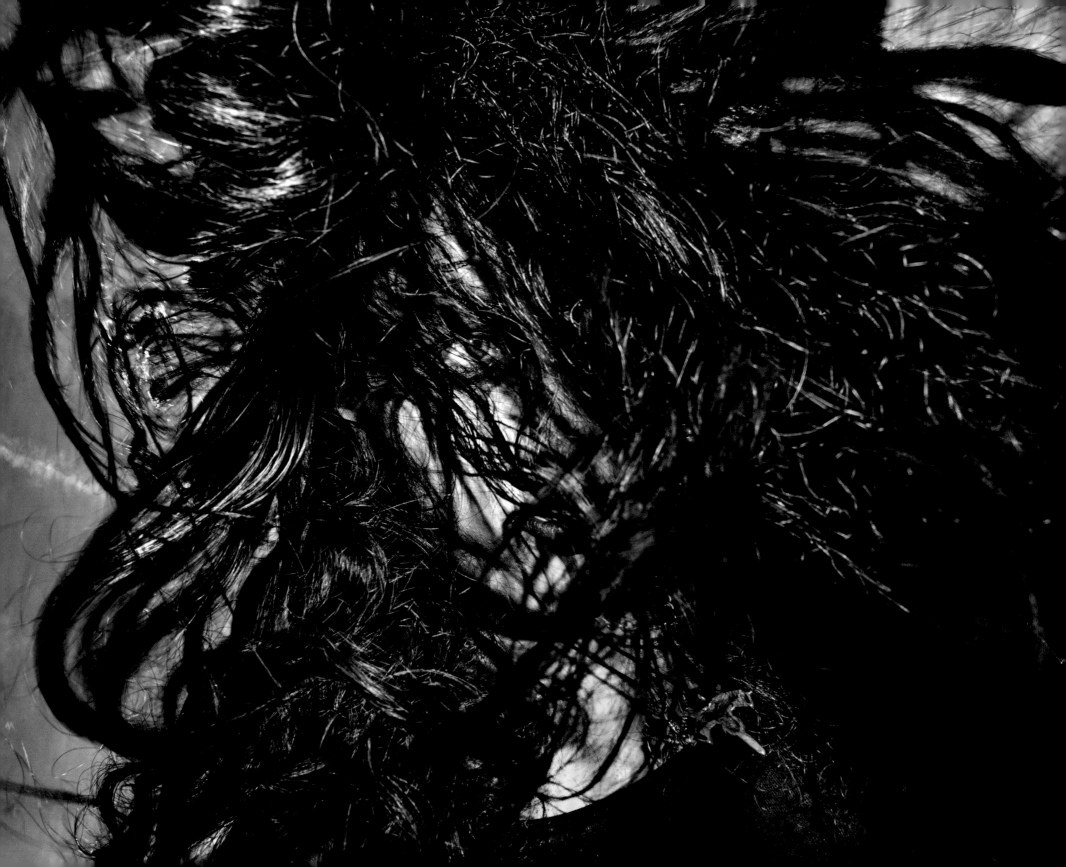

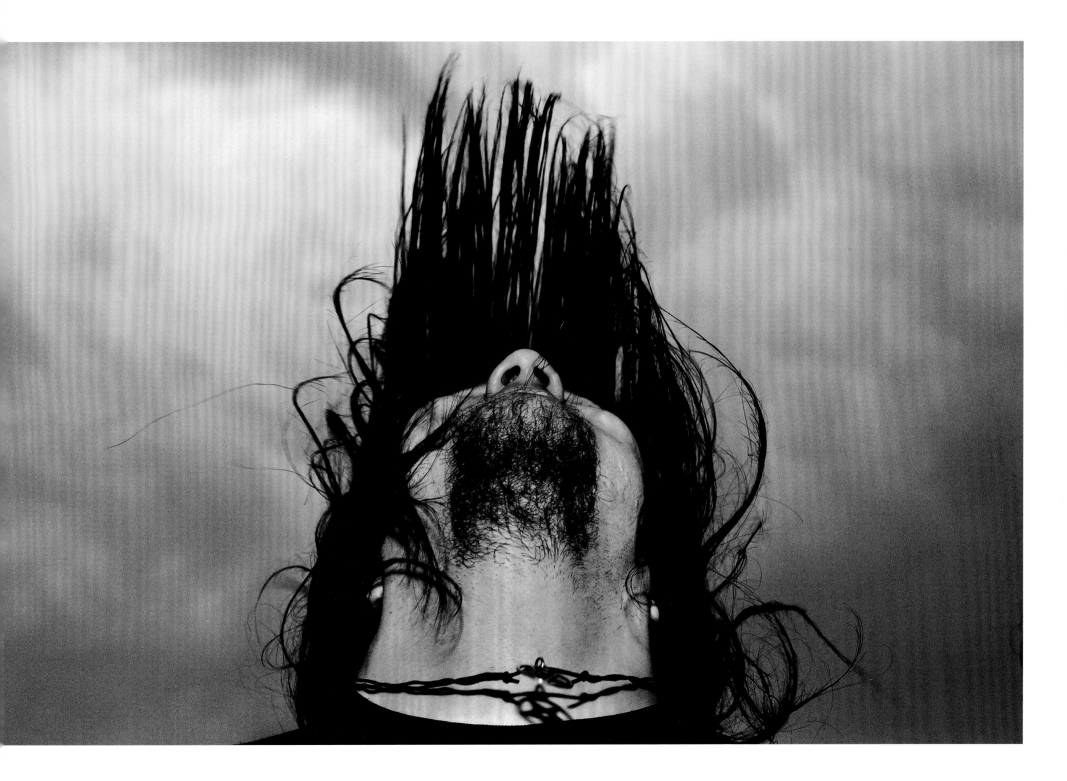

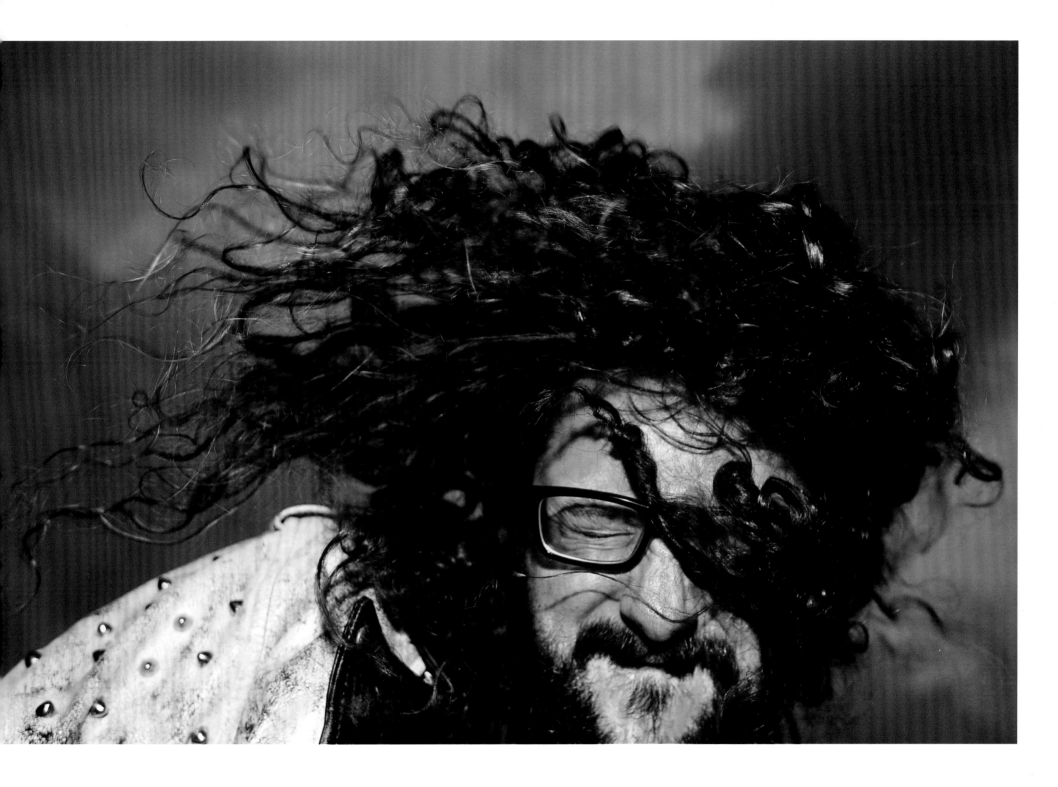

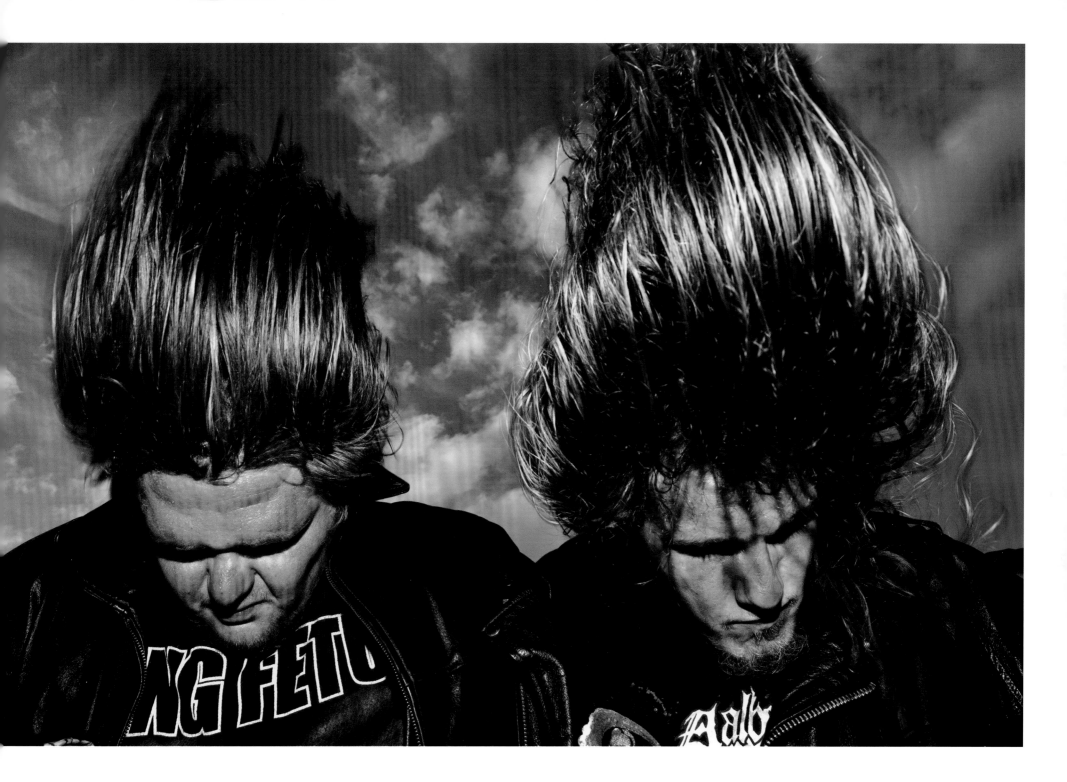

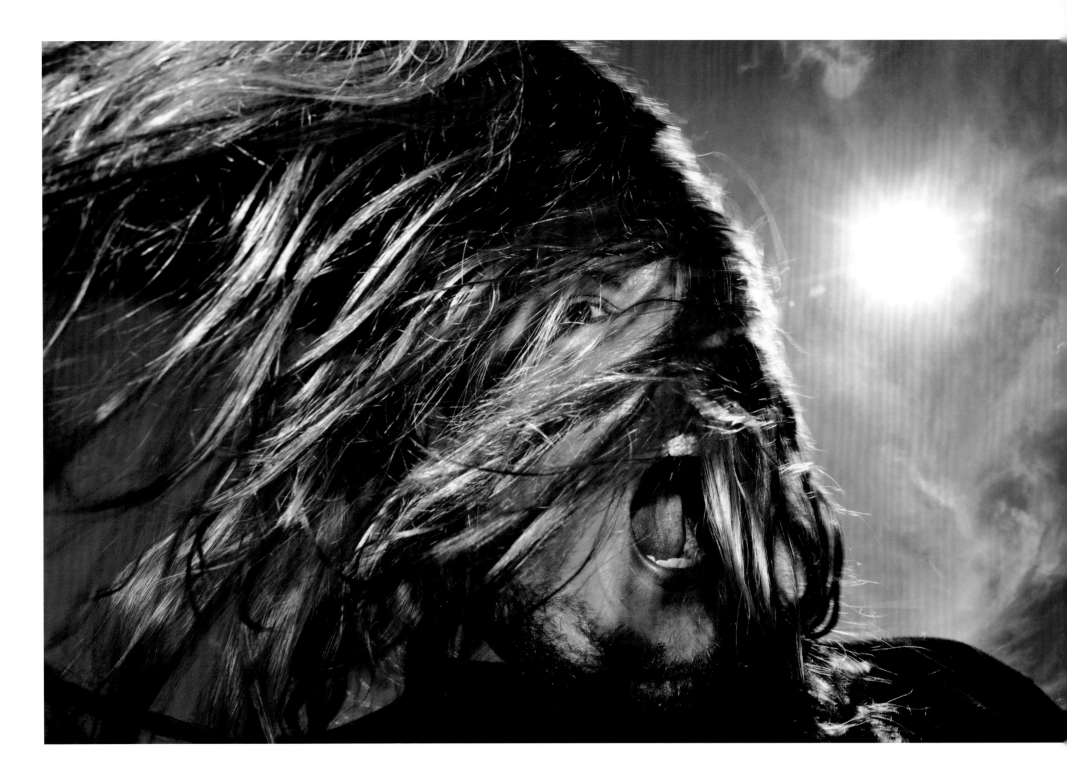

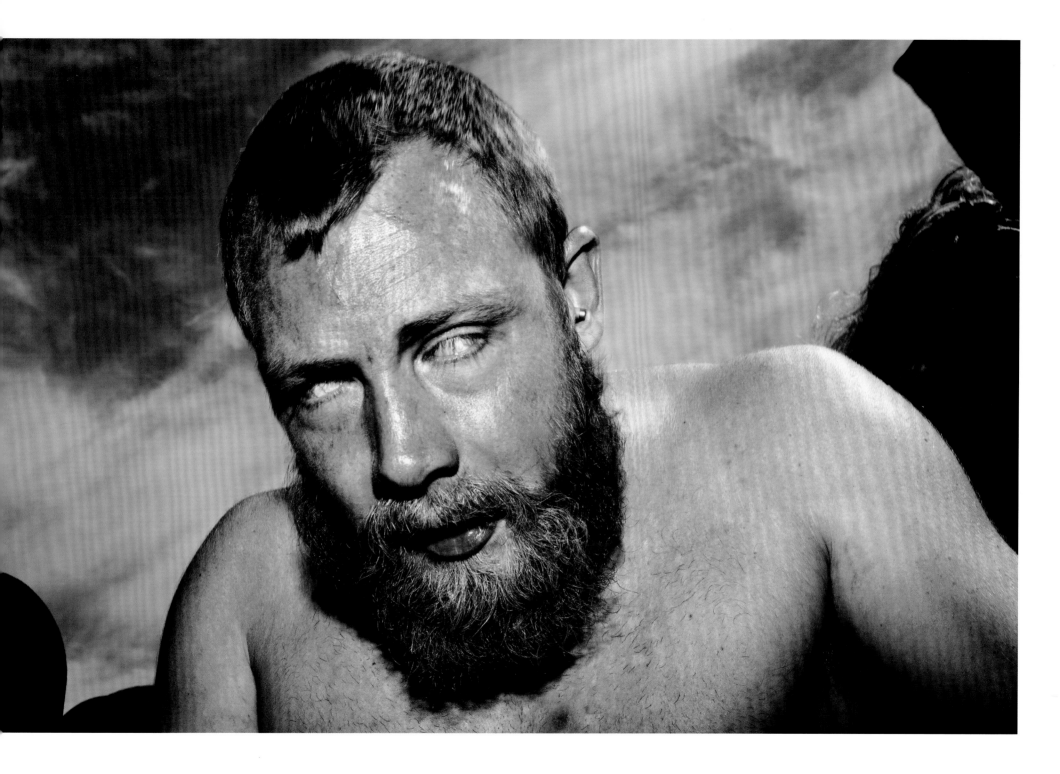

52

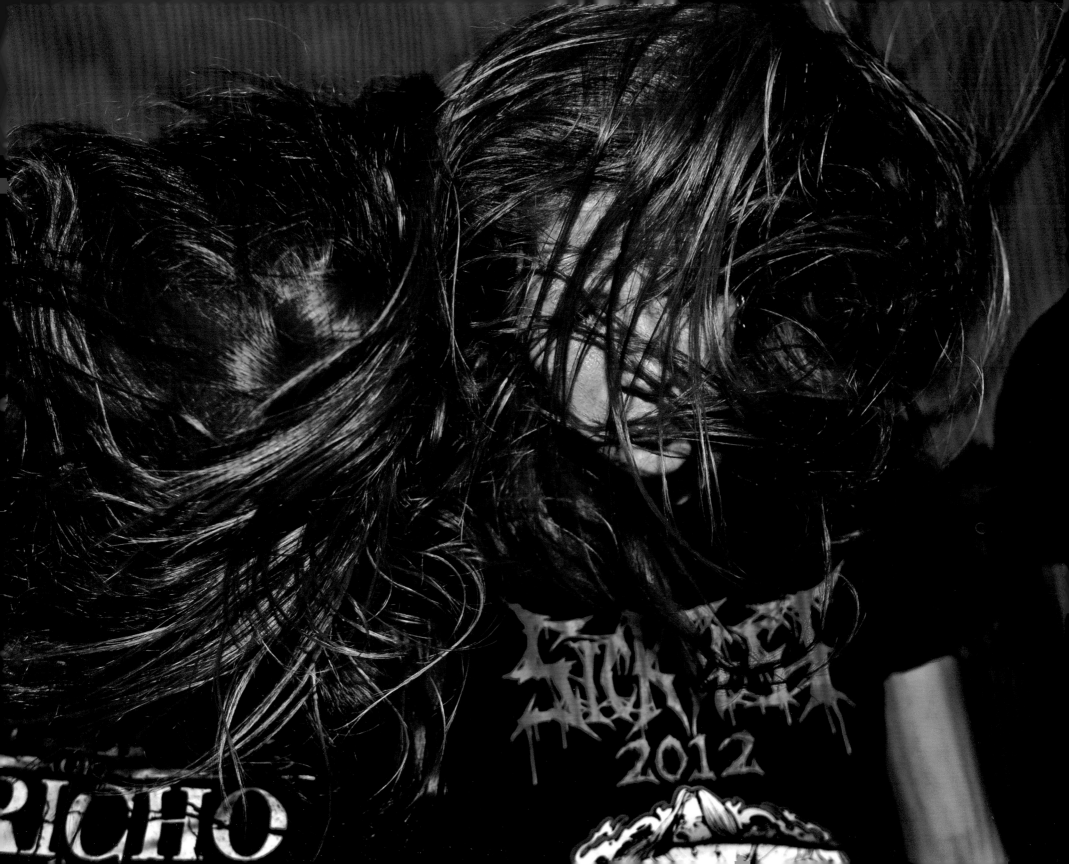

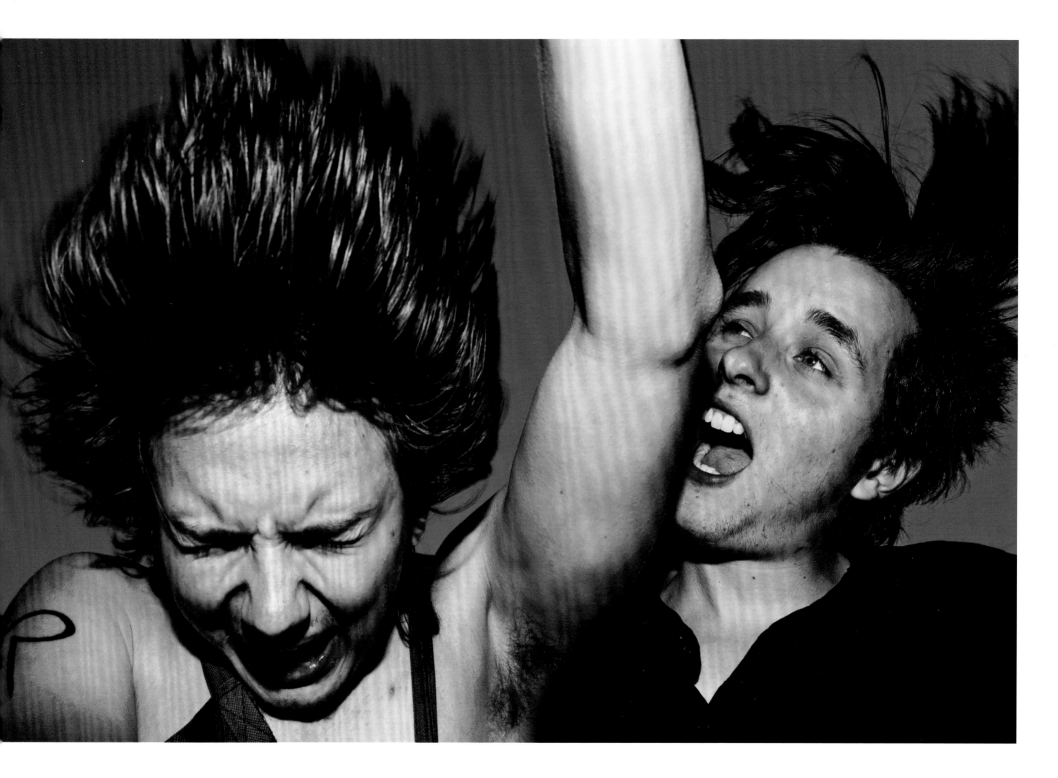

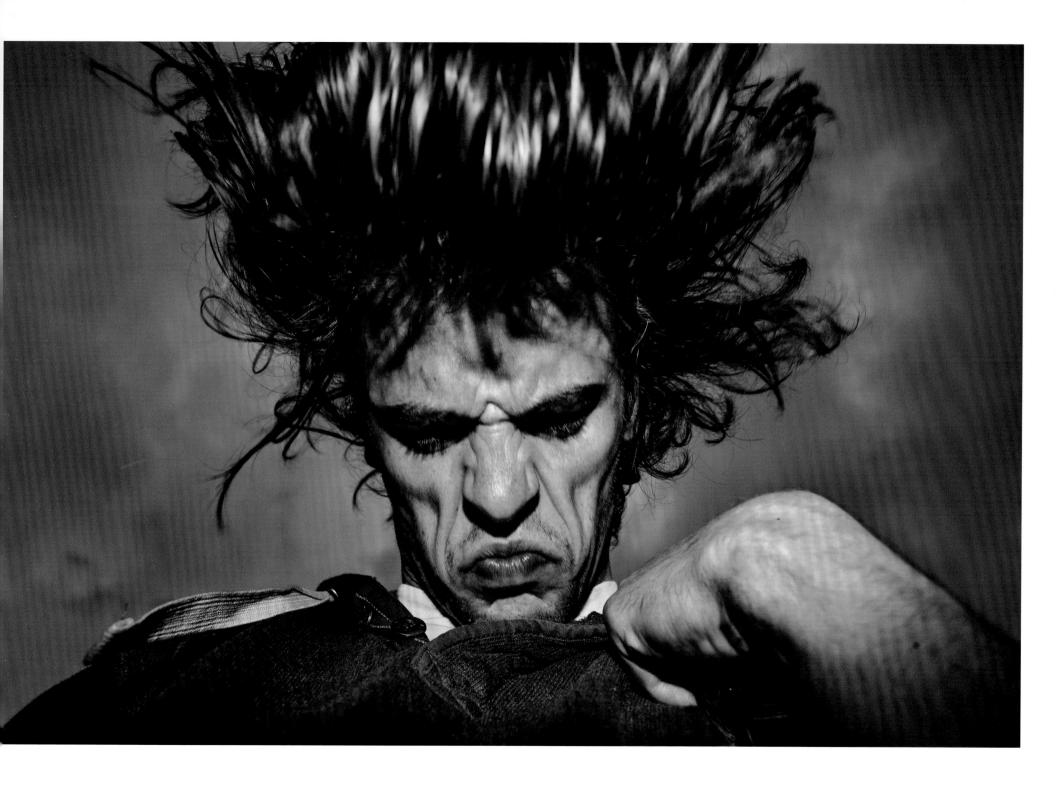

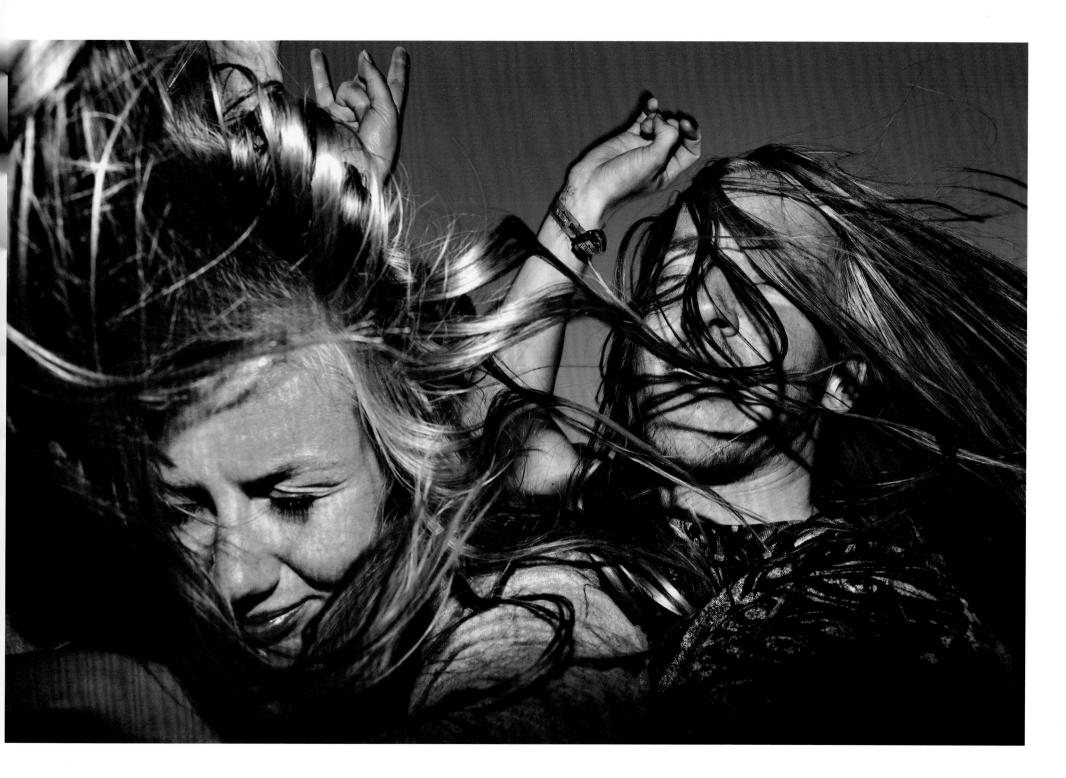

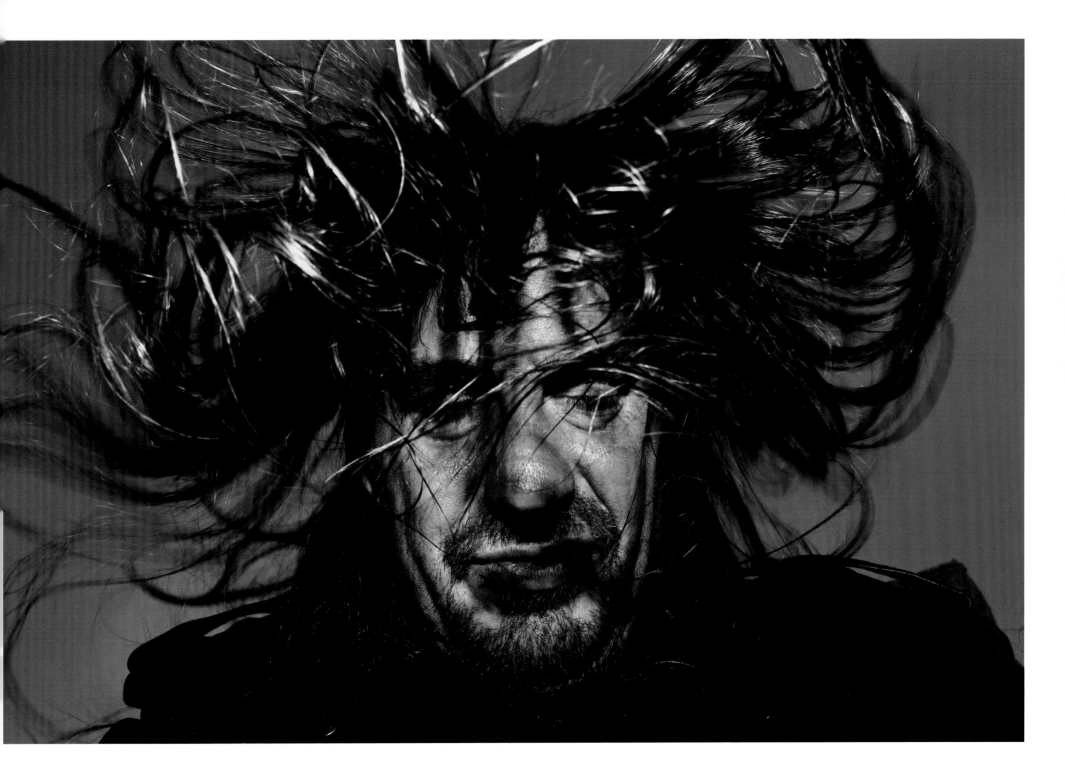

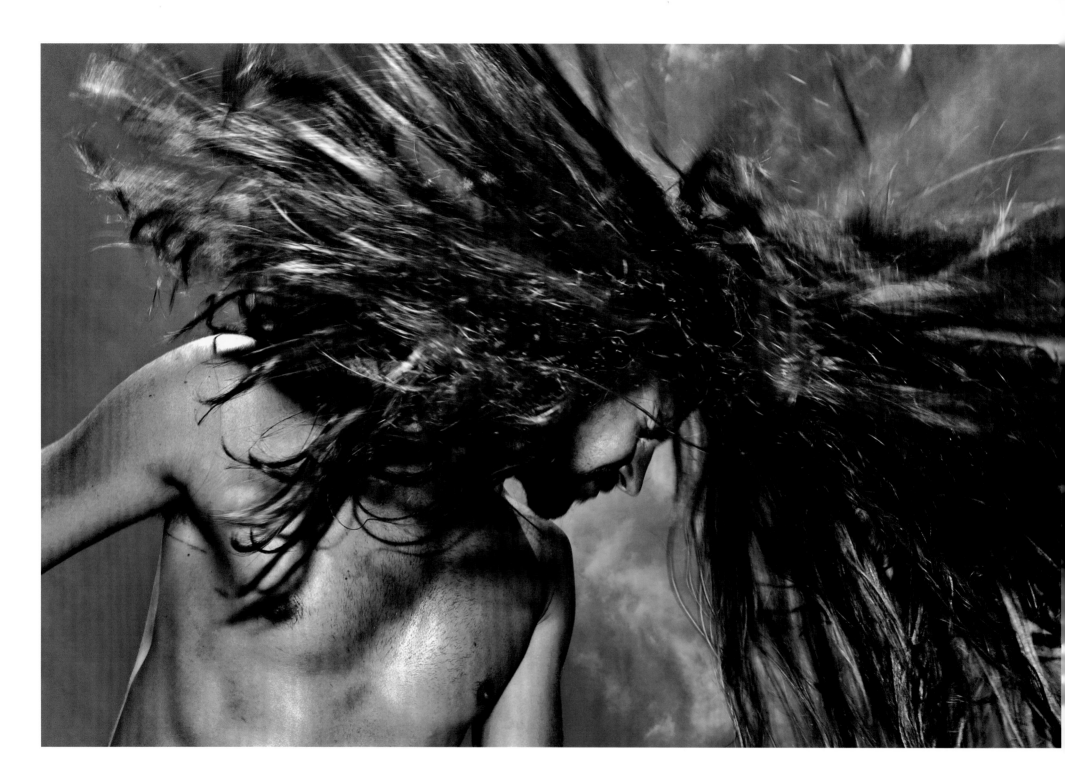

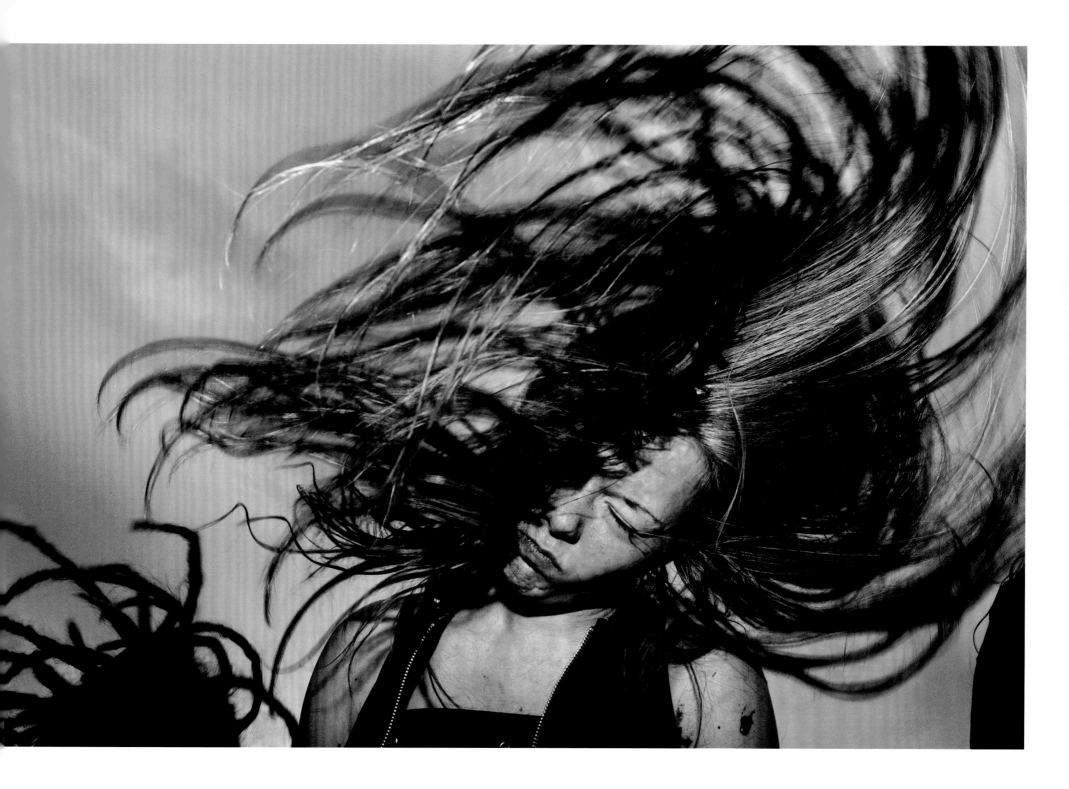

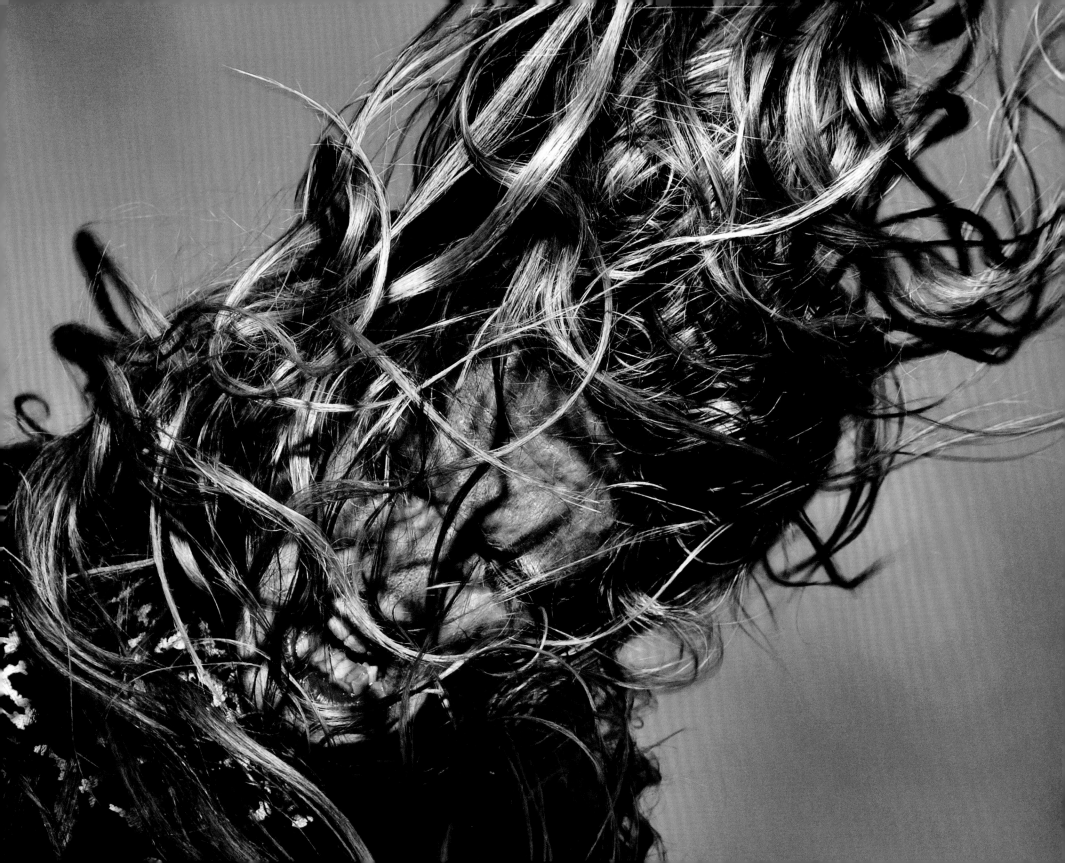

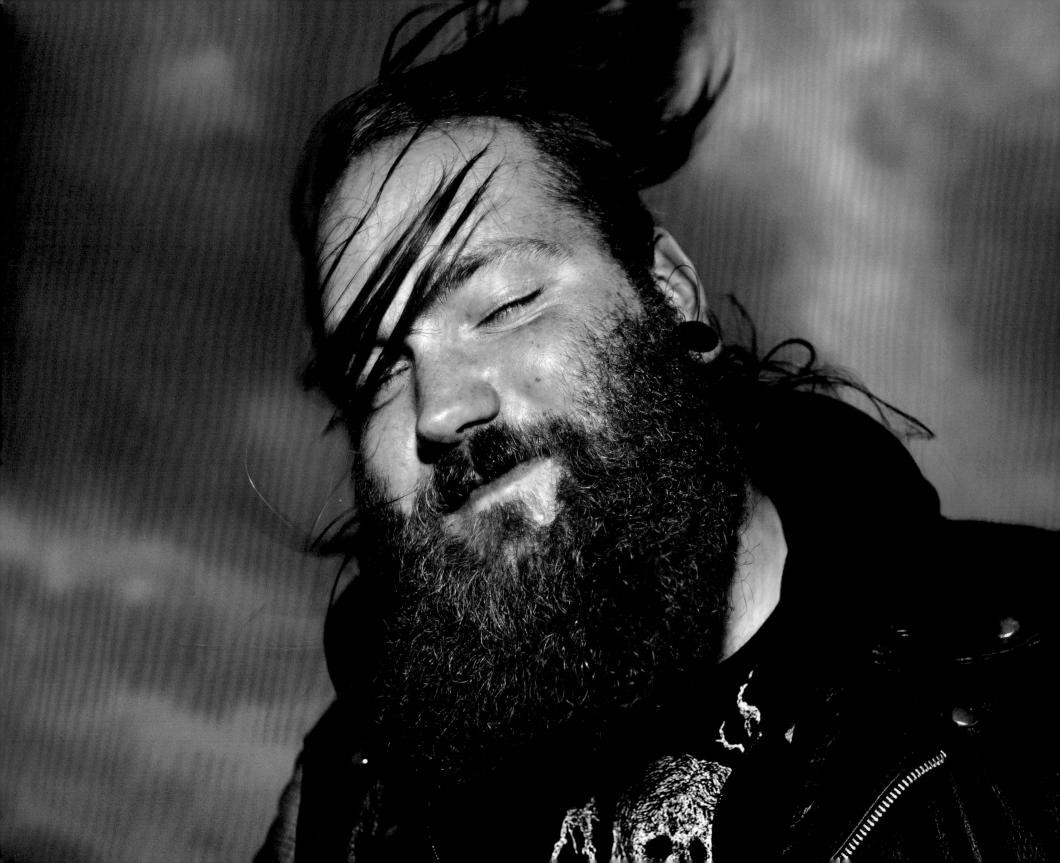

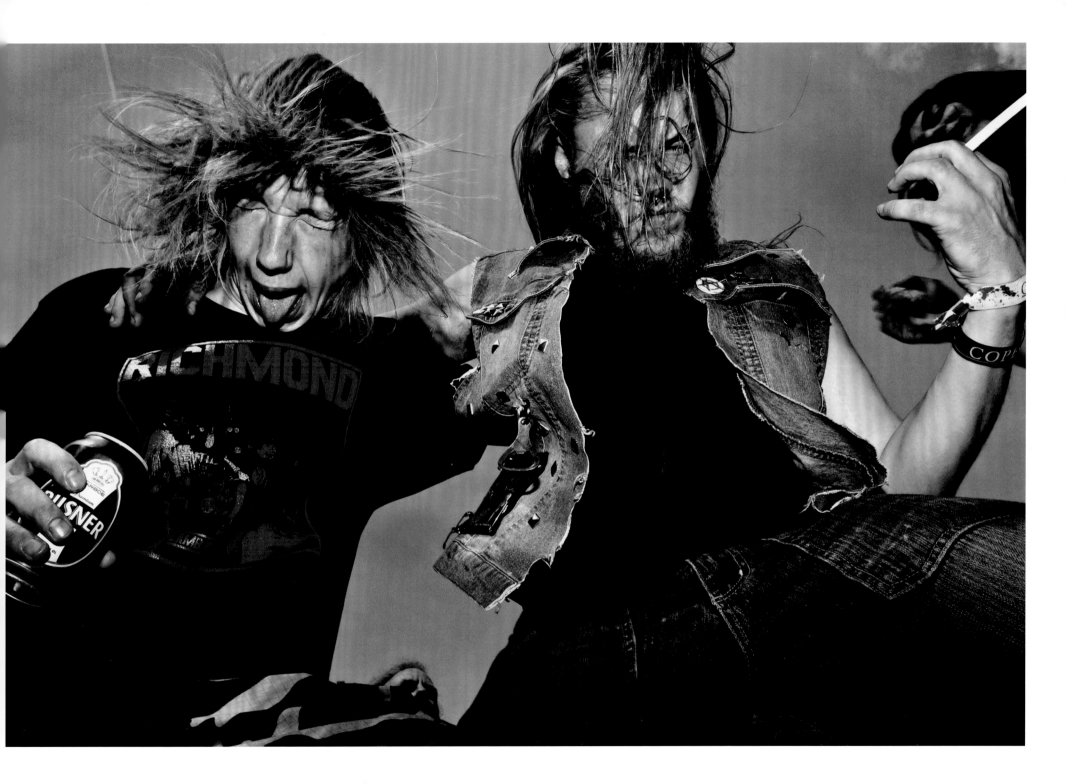

70

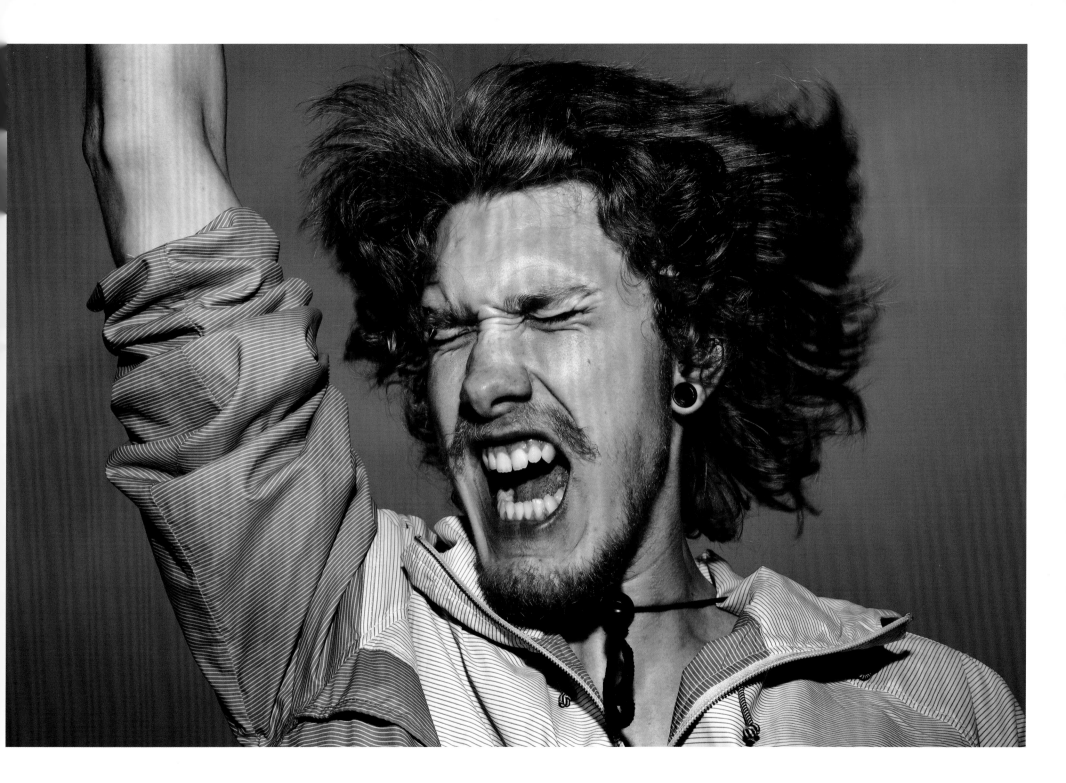

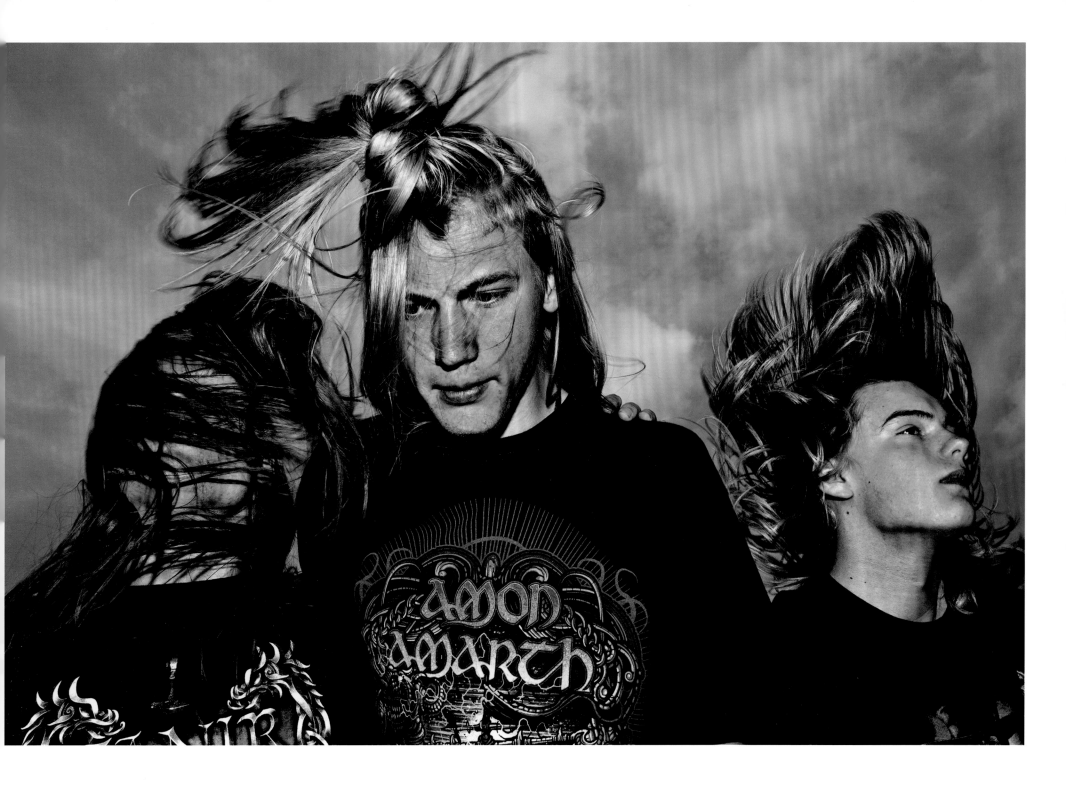

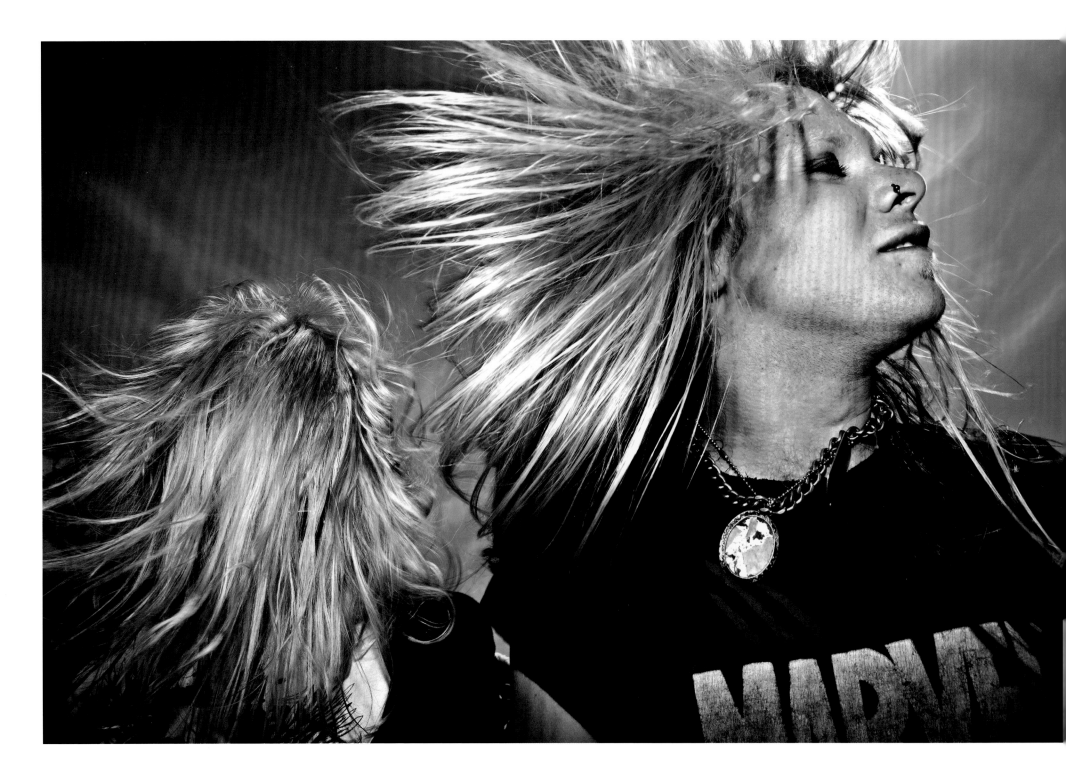

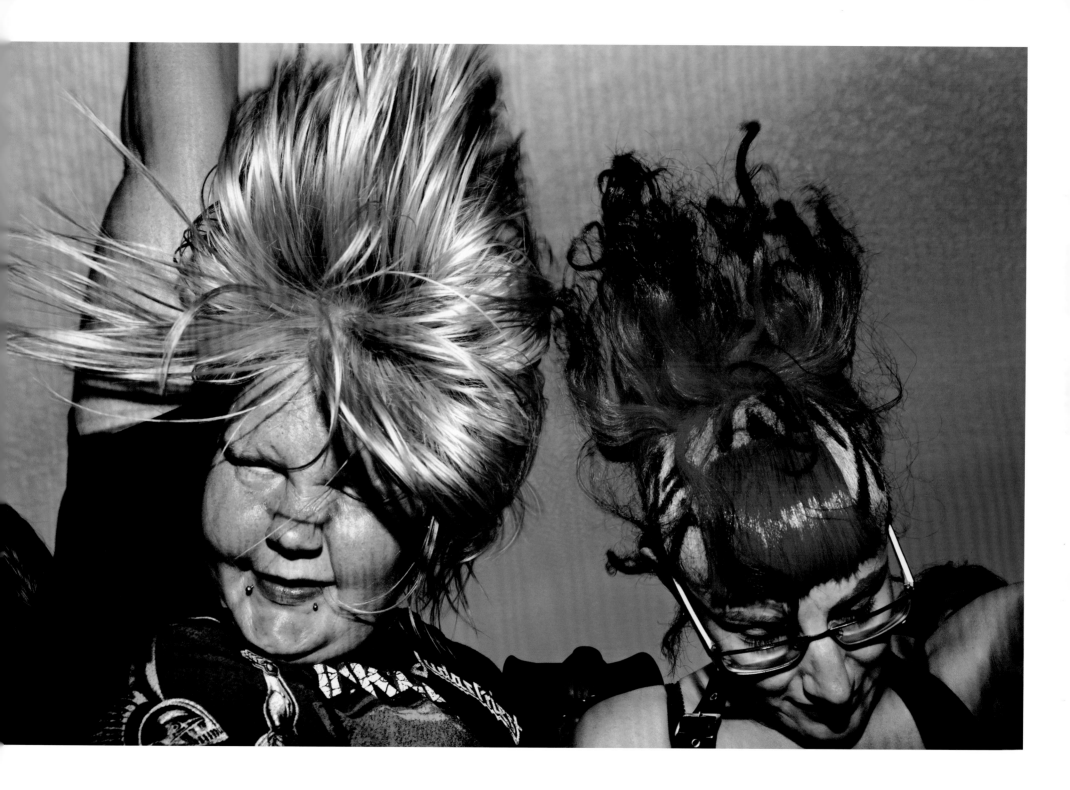

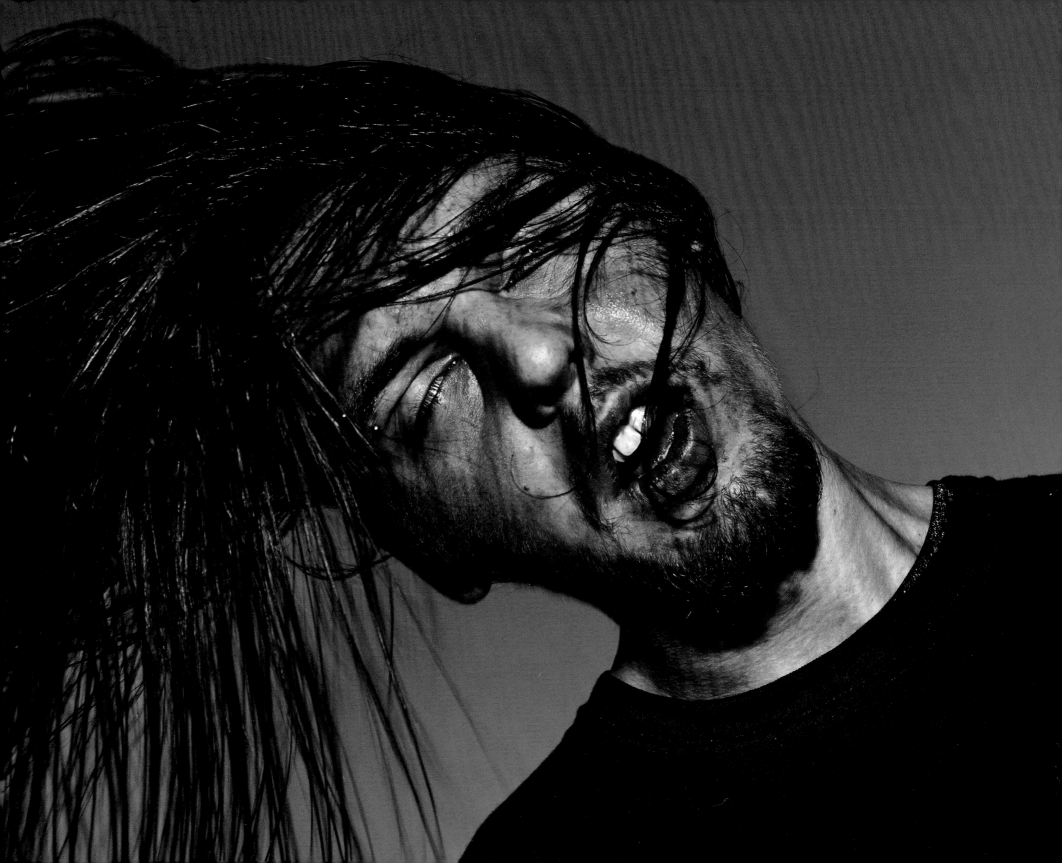

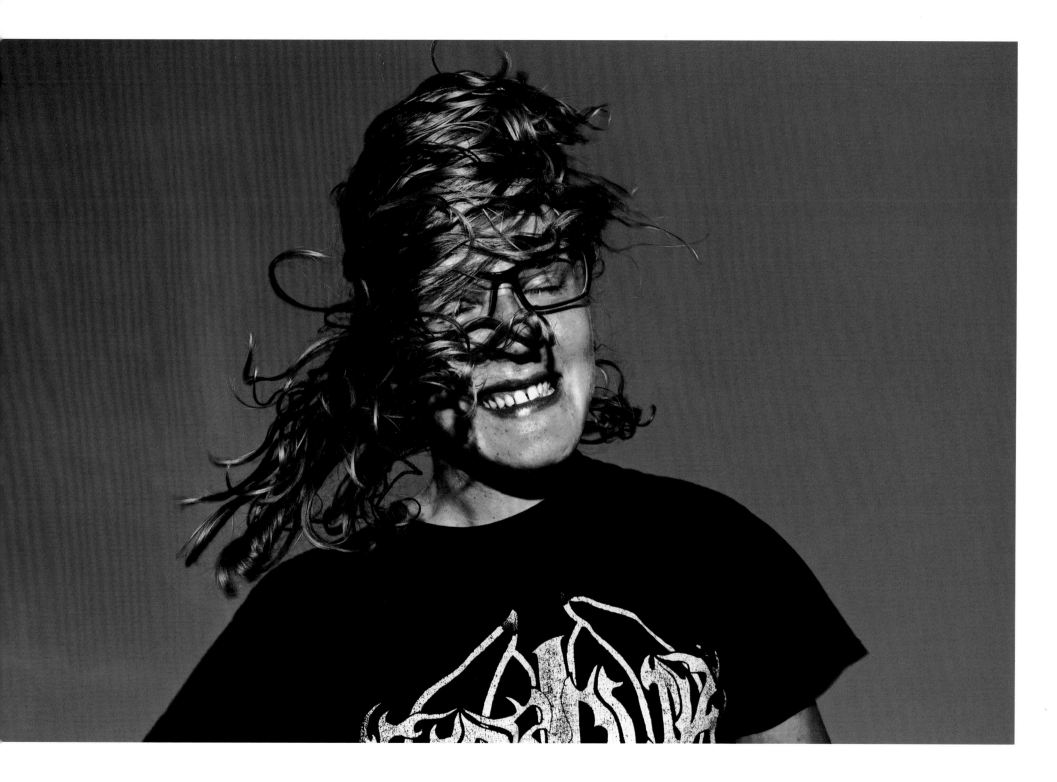

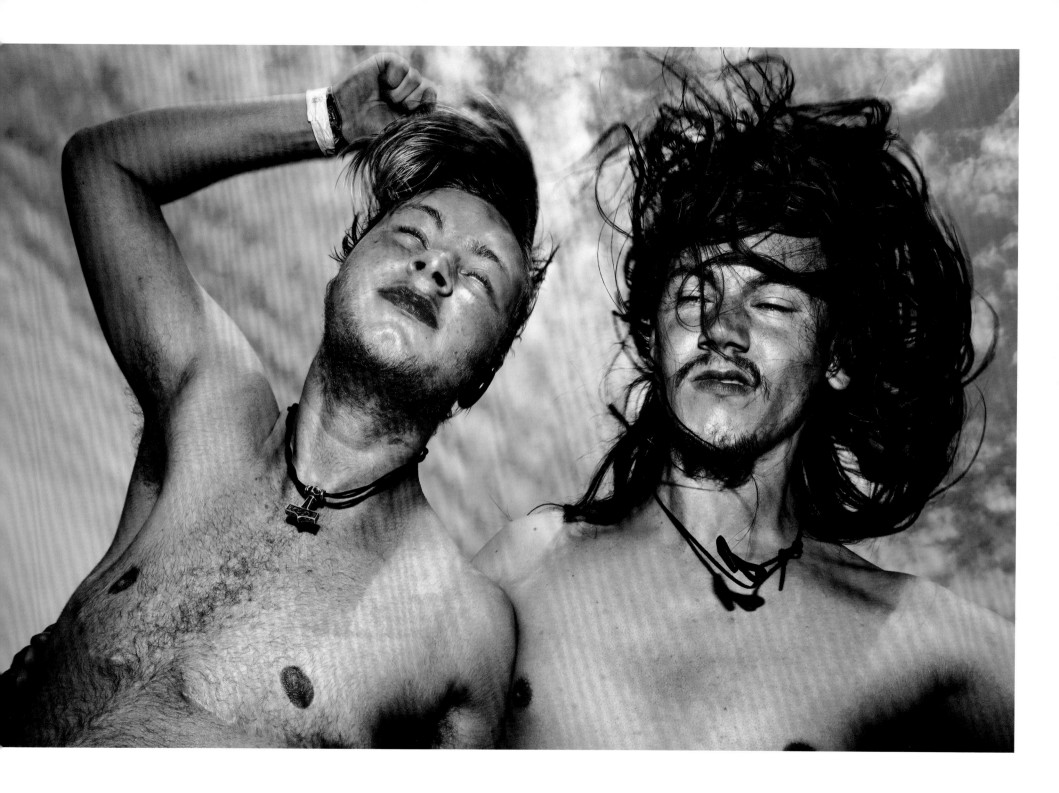

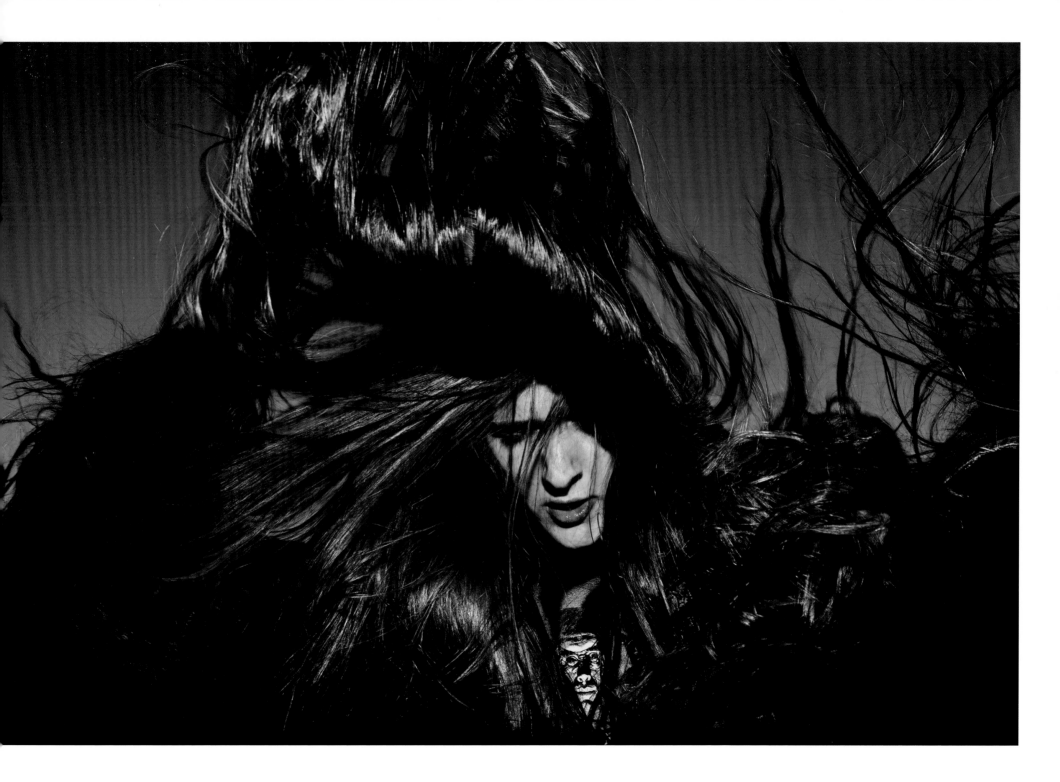

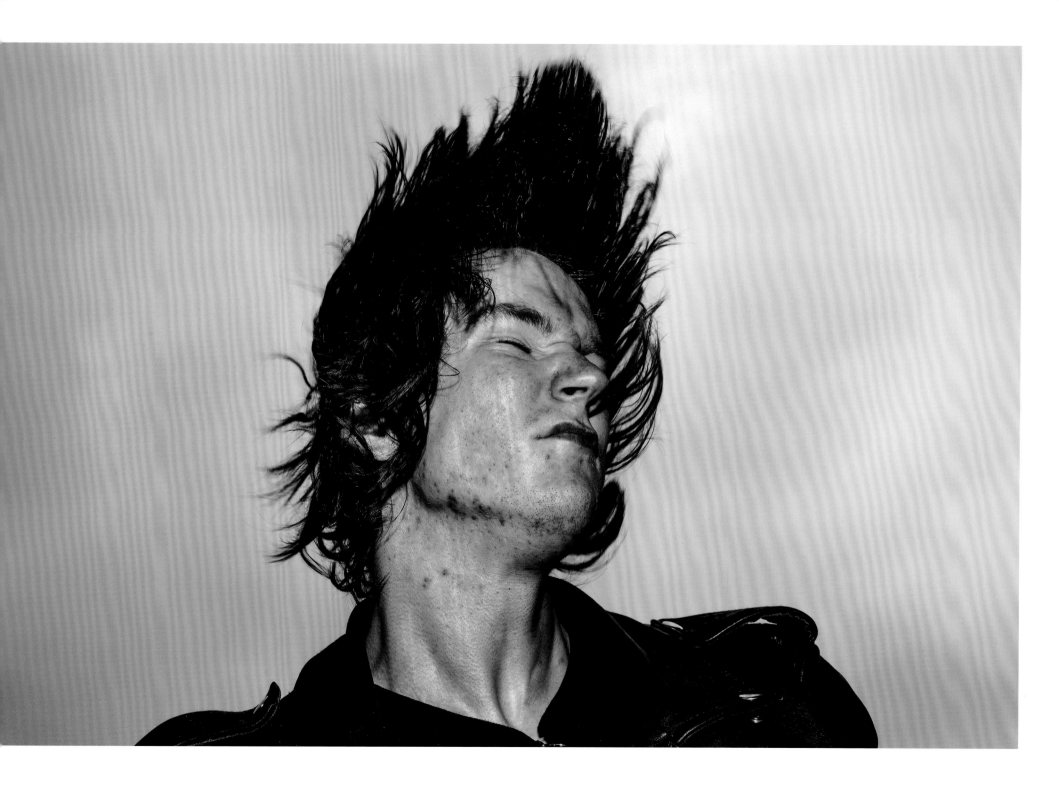

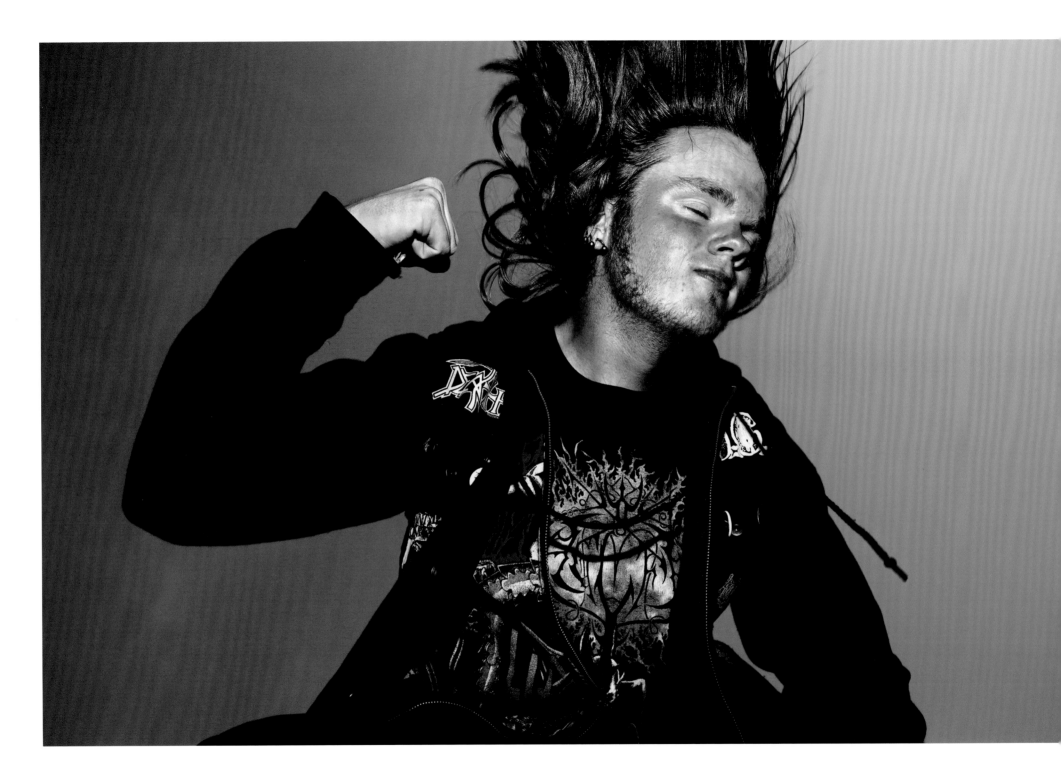

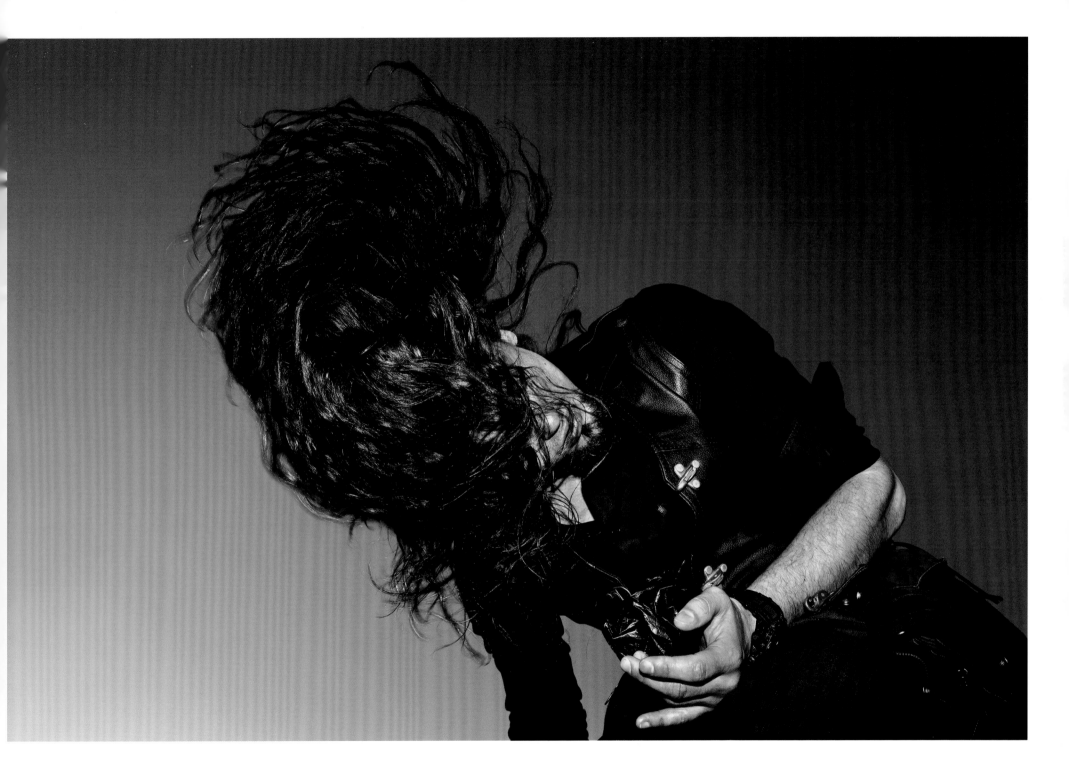

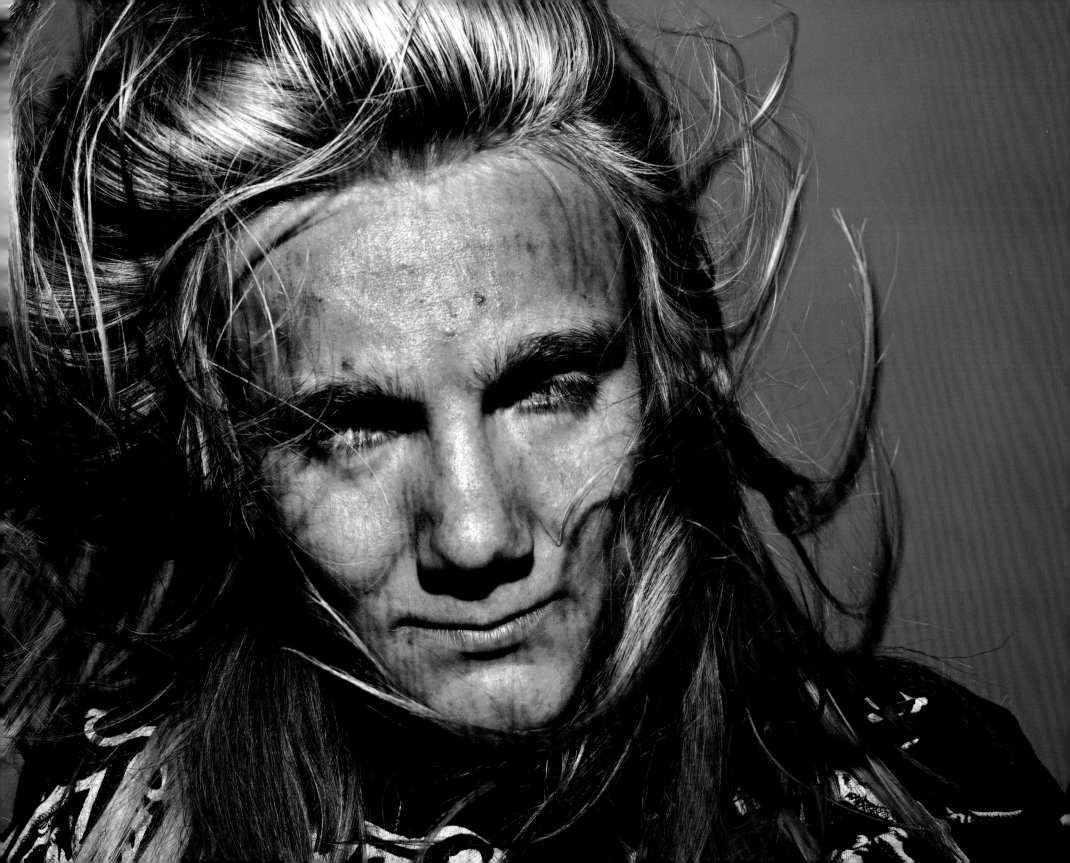

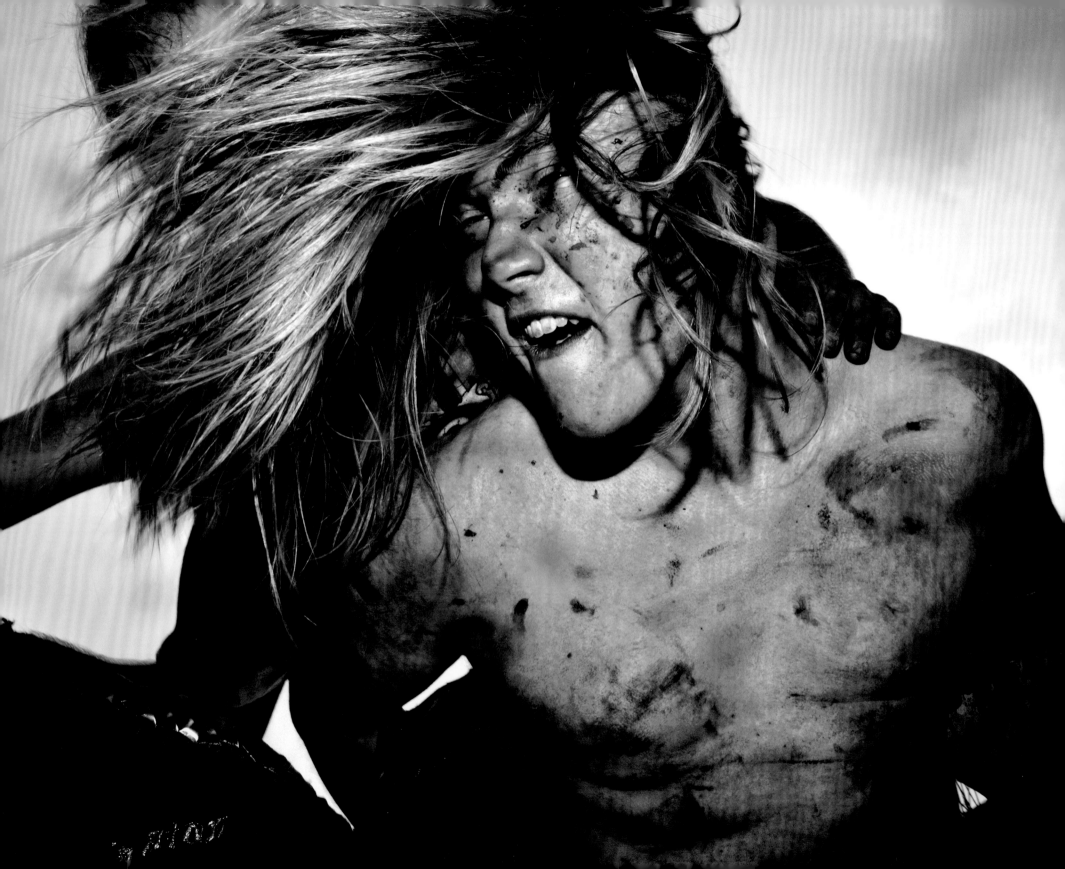

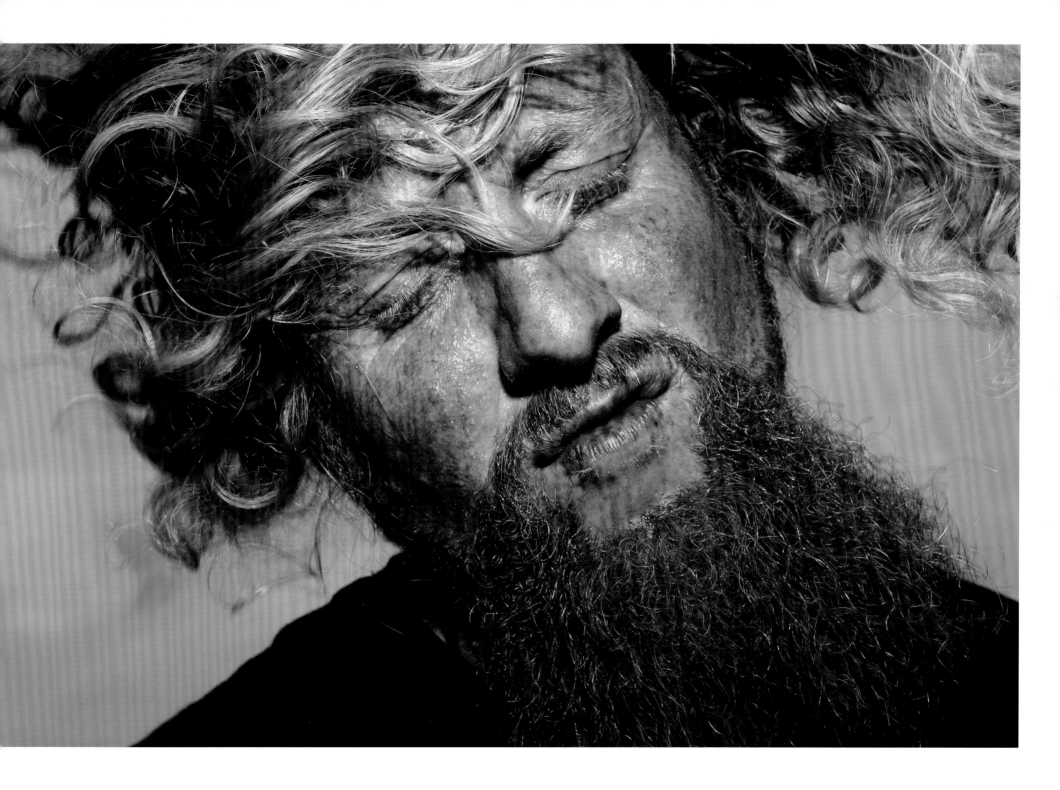

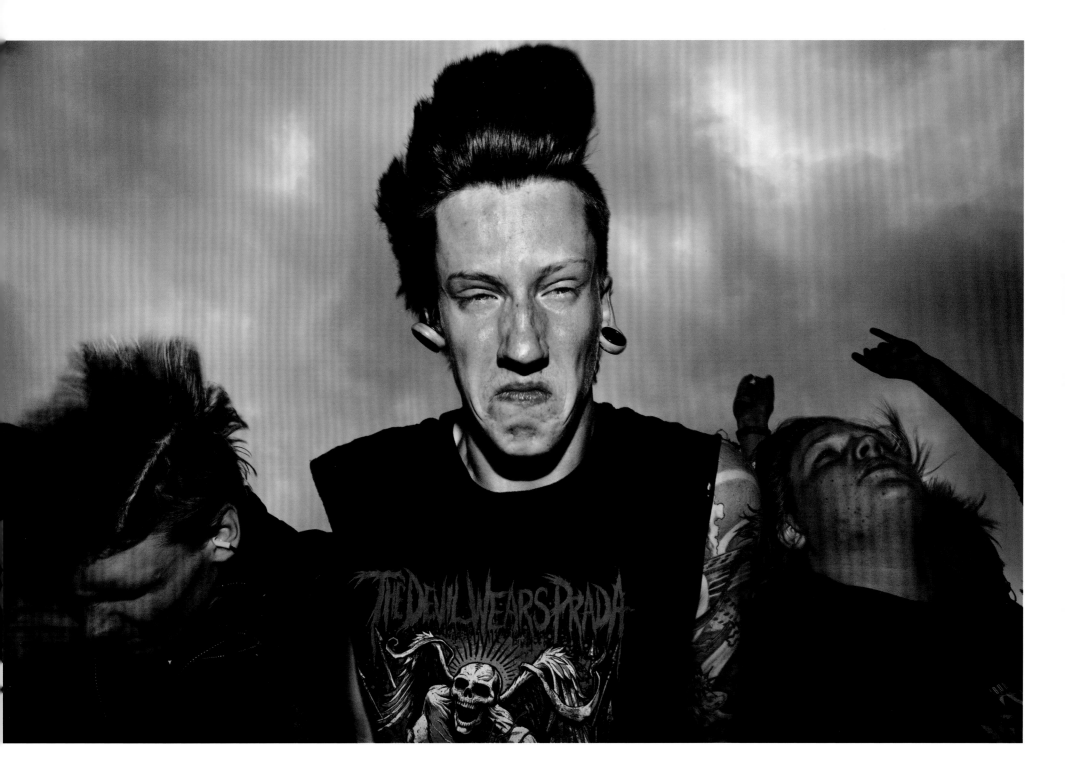

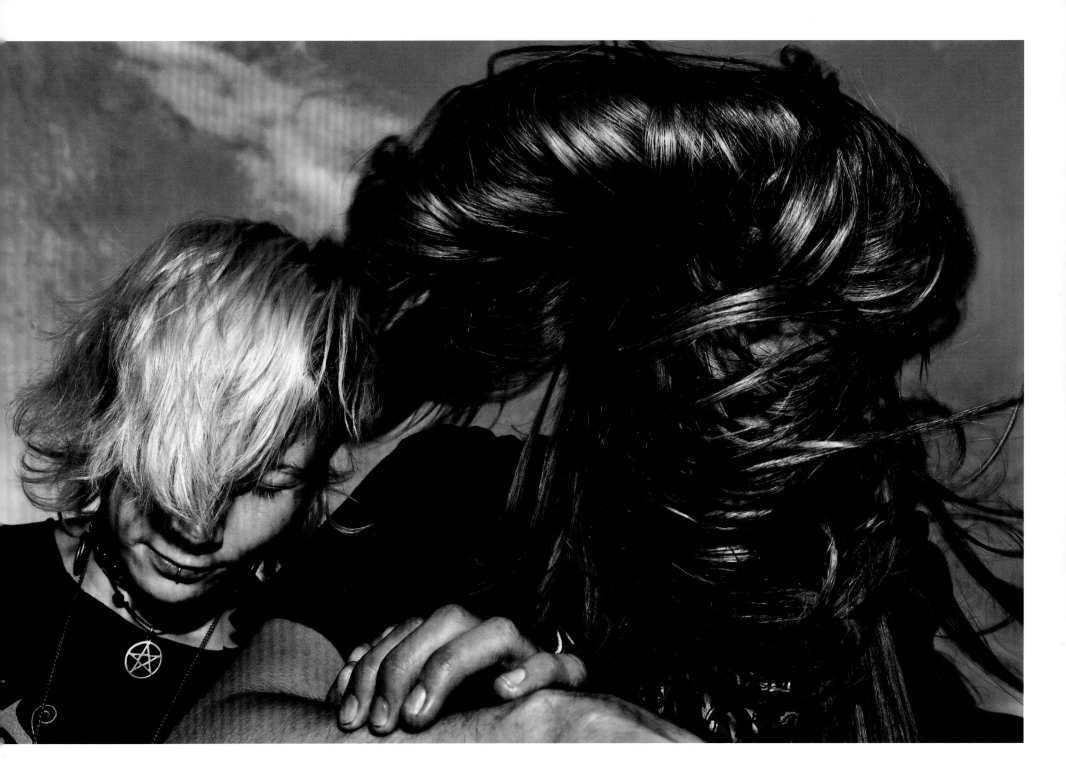

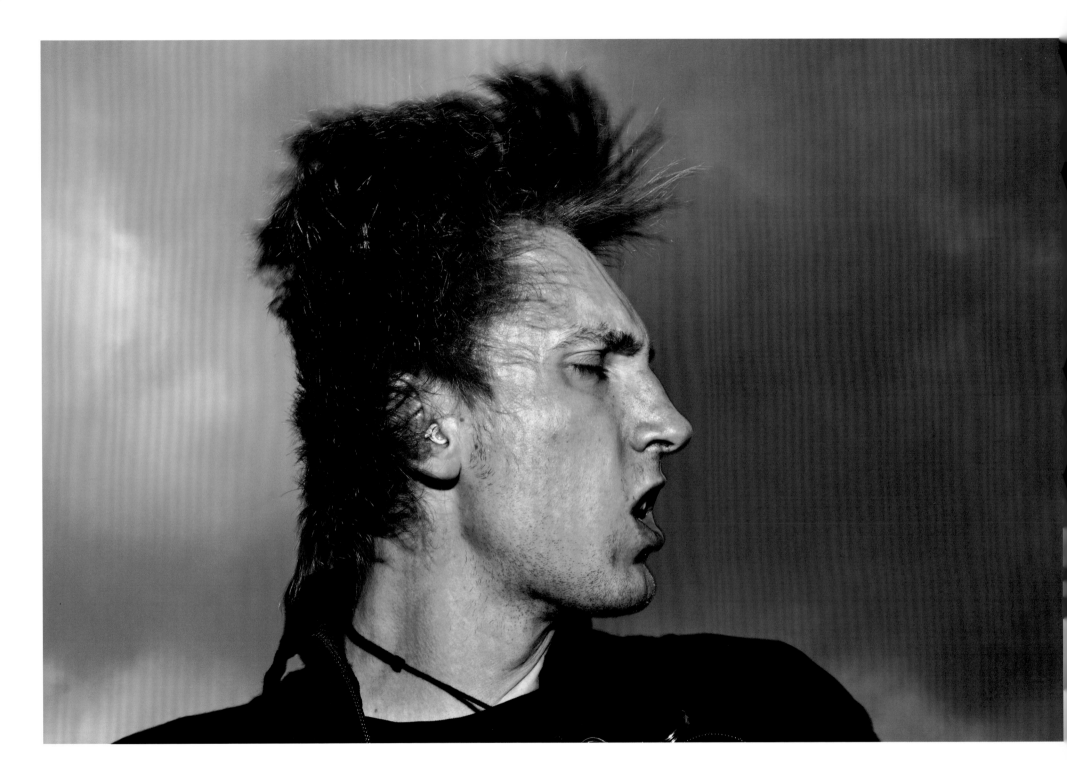

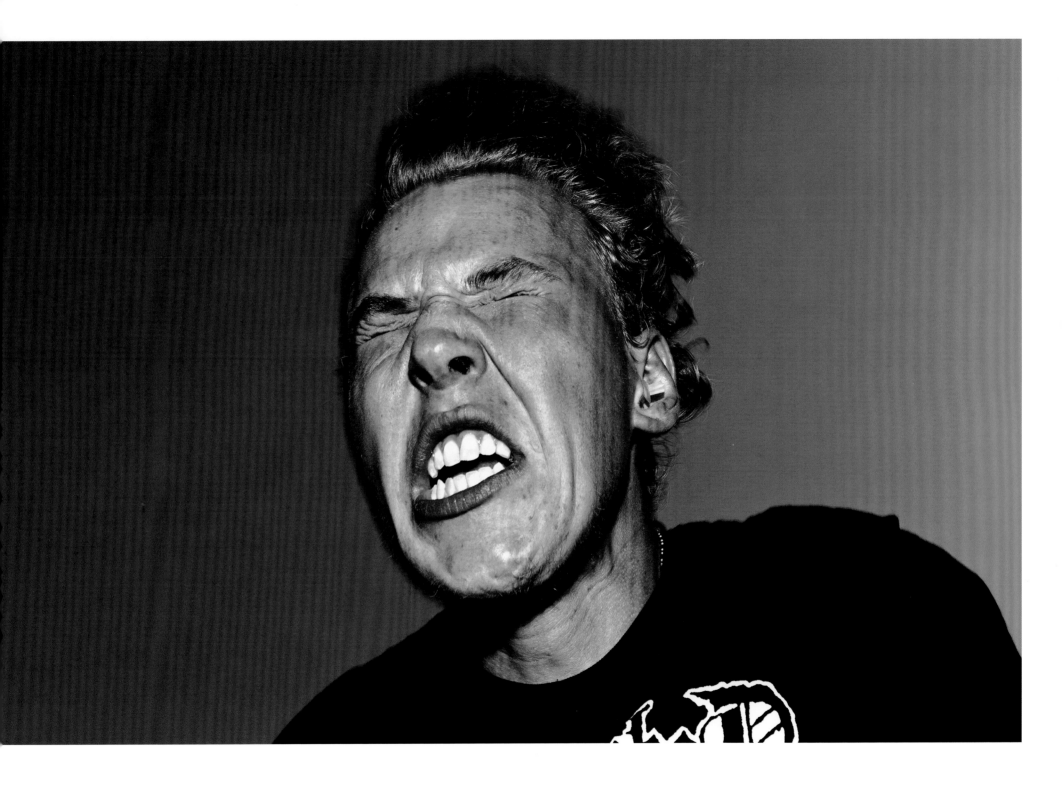

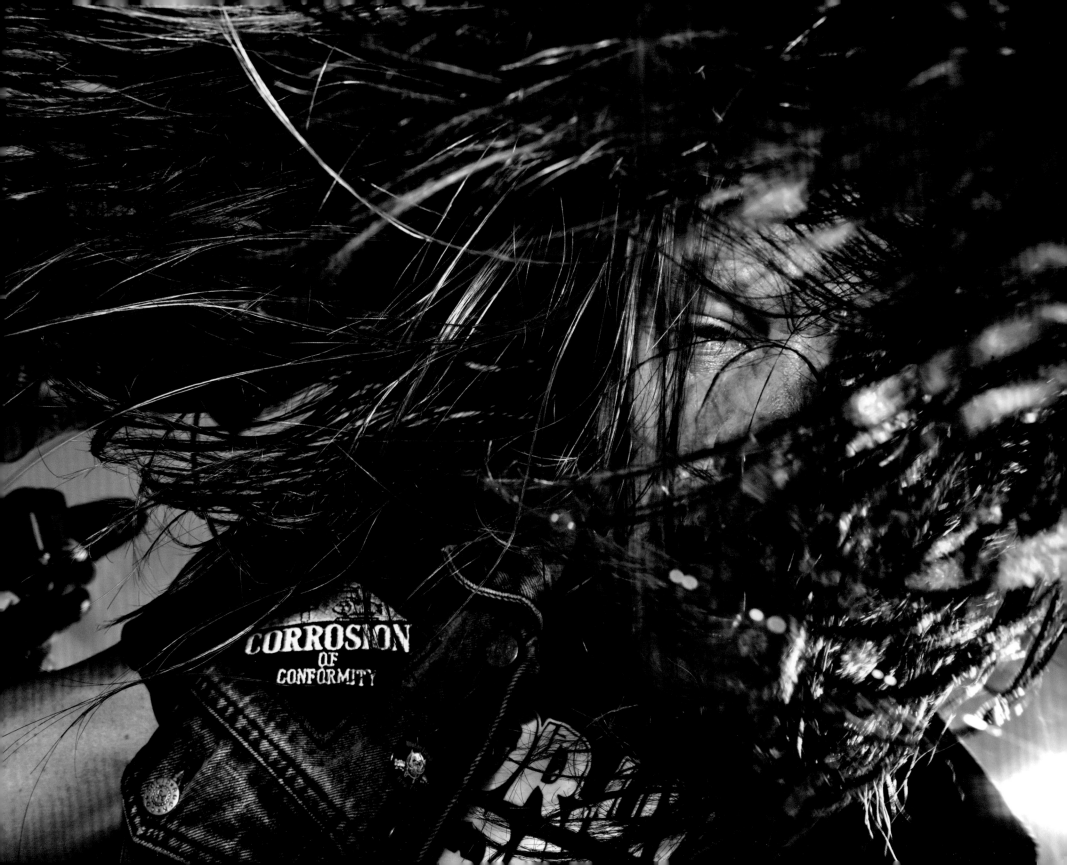

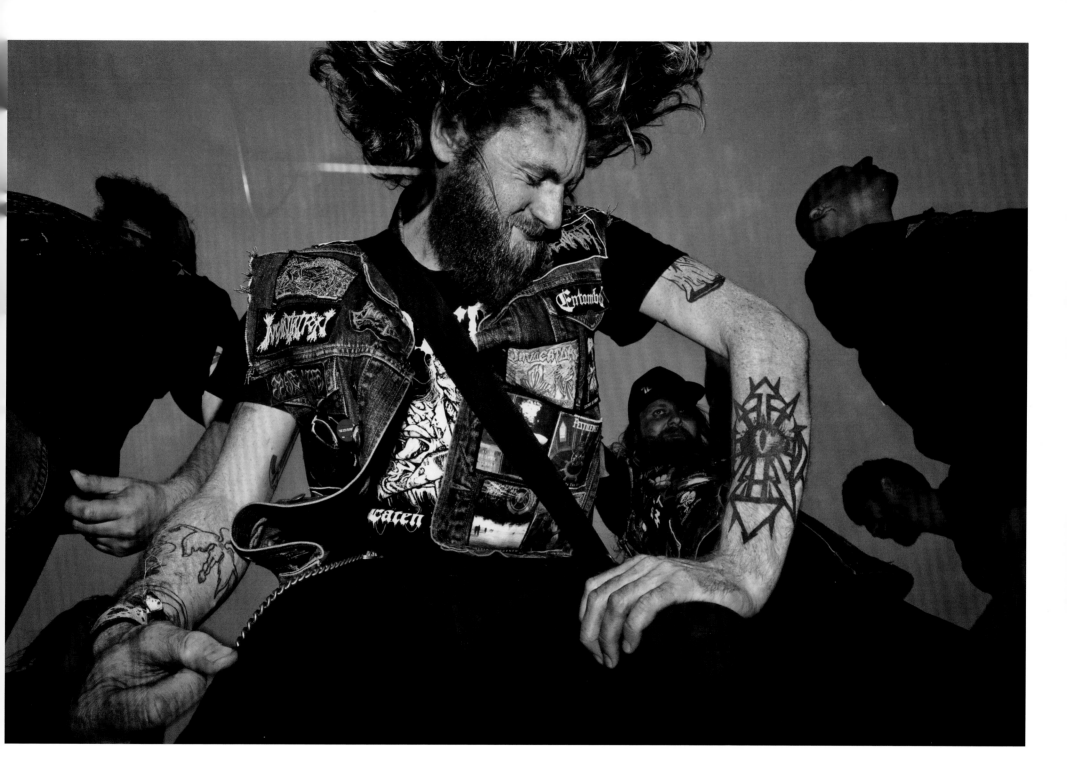

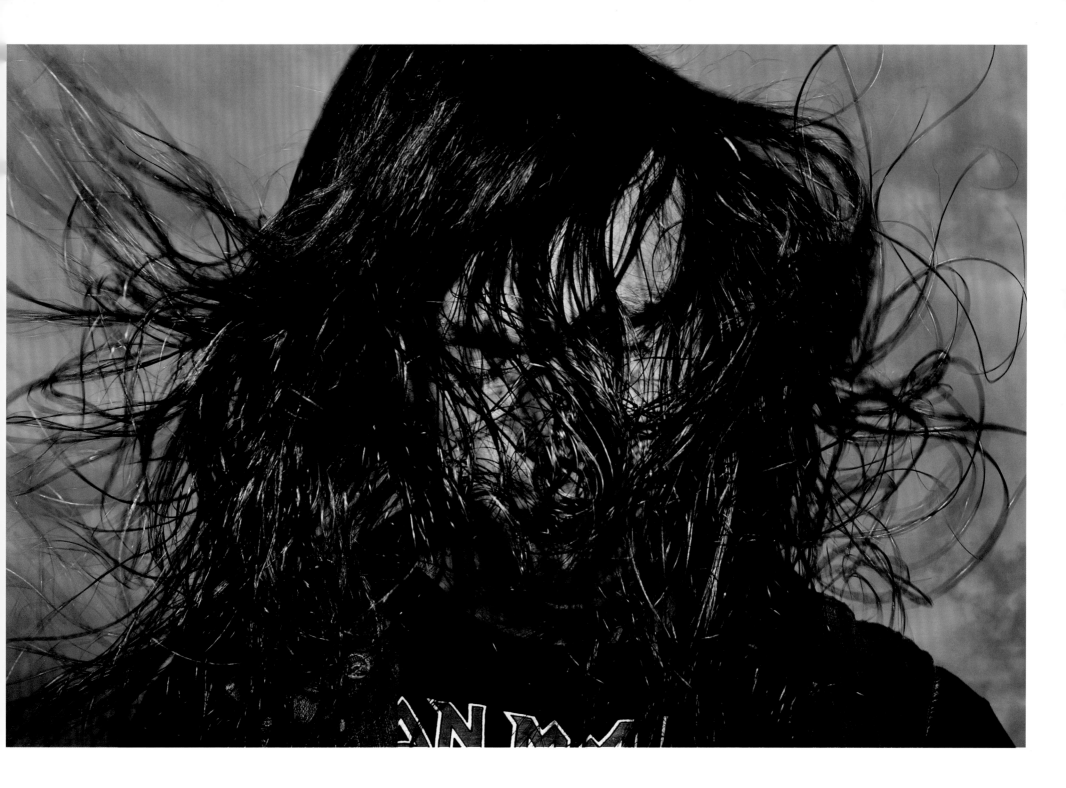

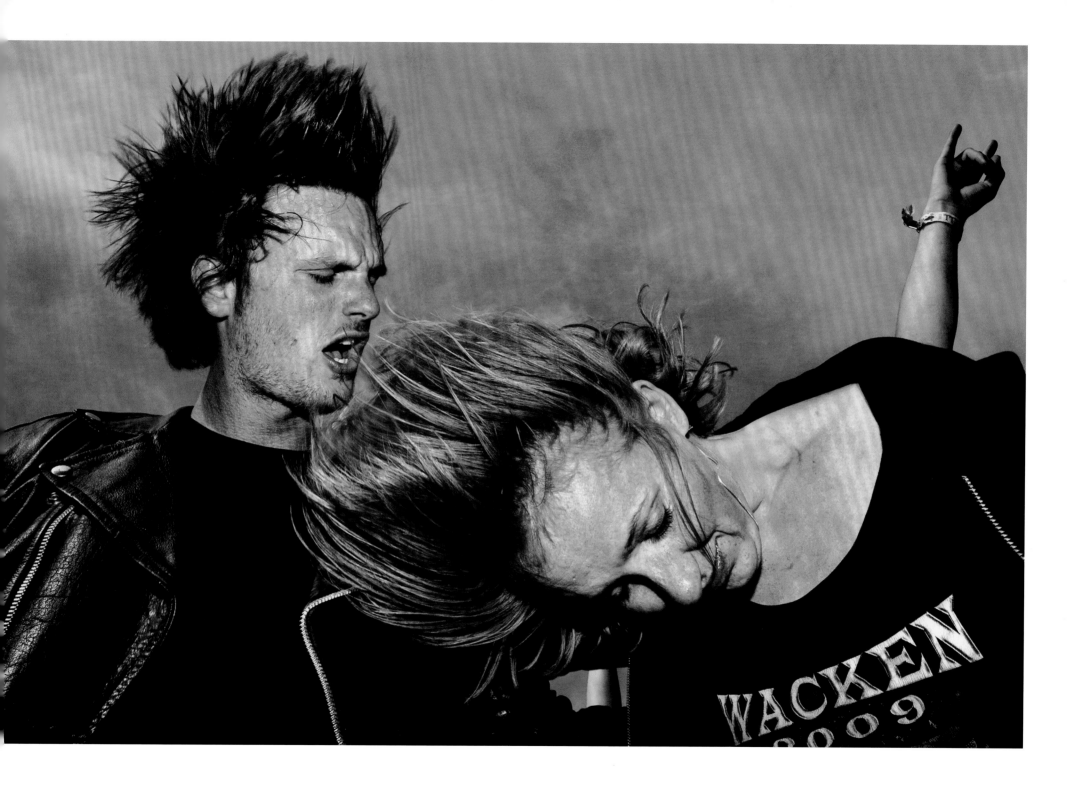

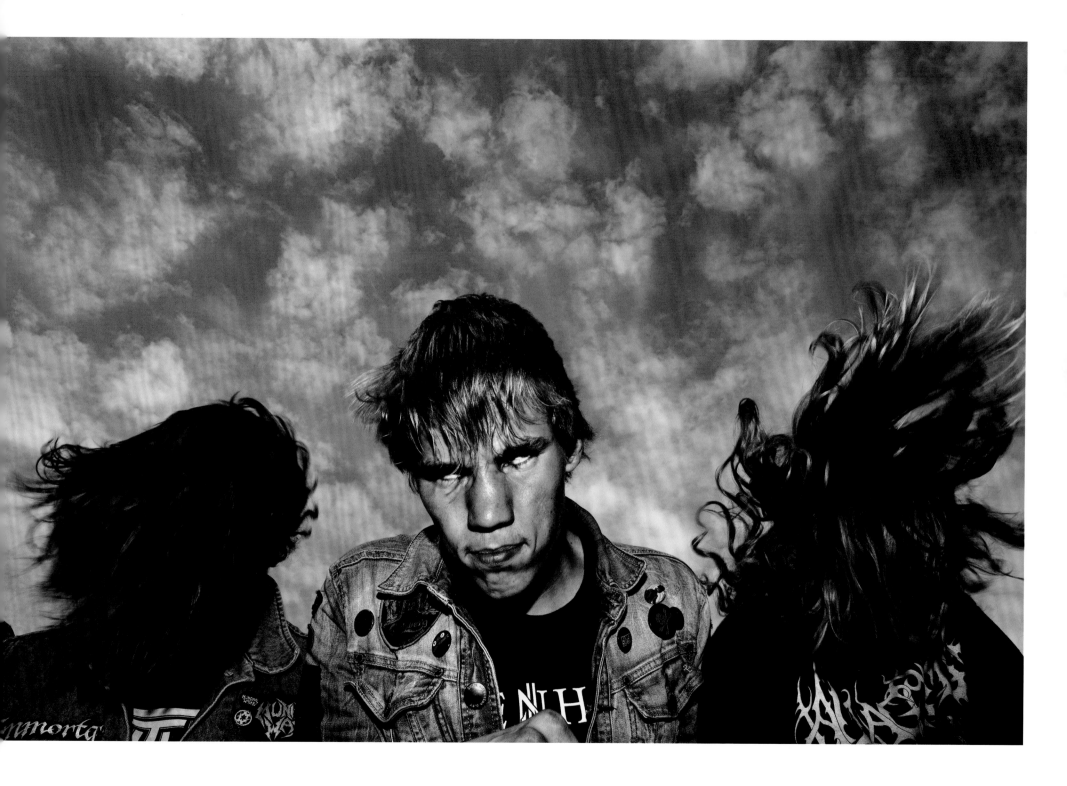

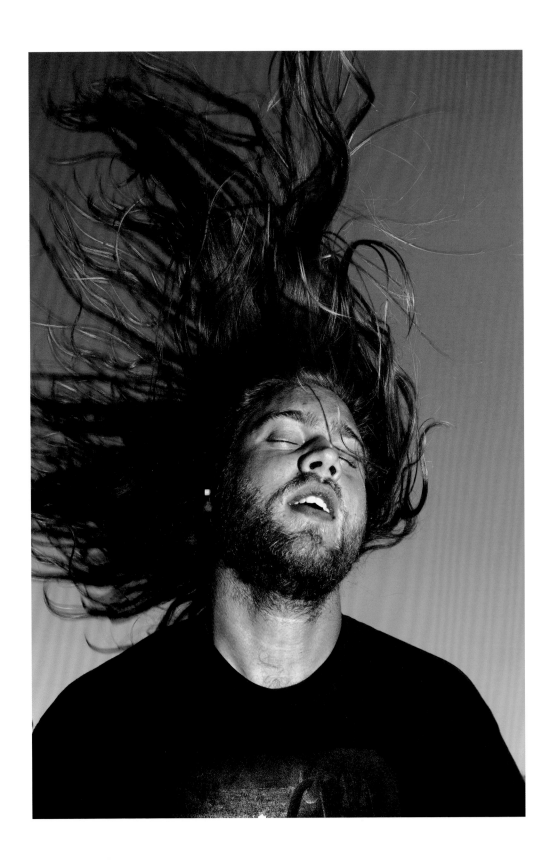

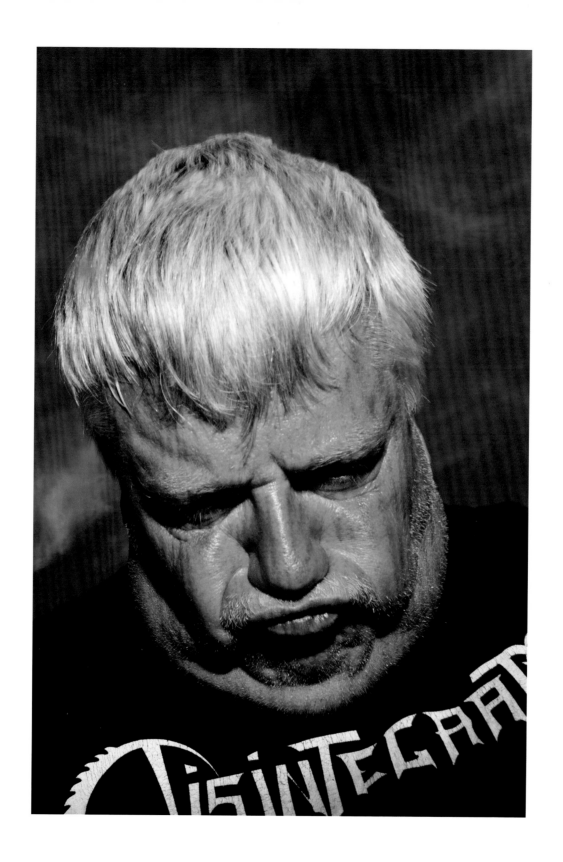

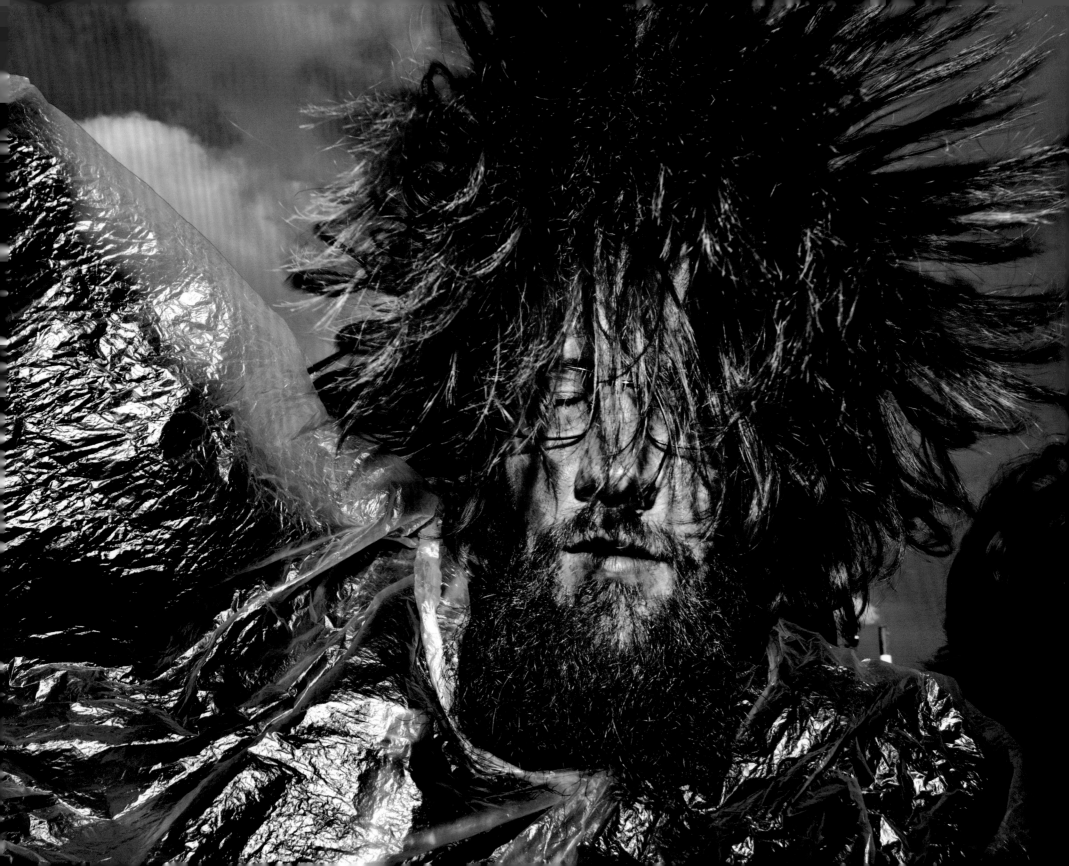

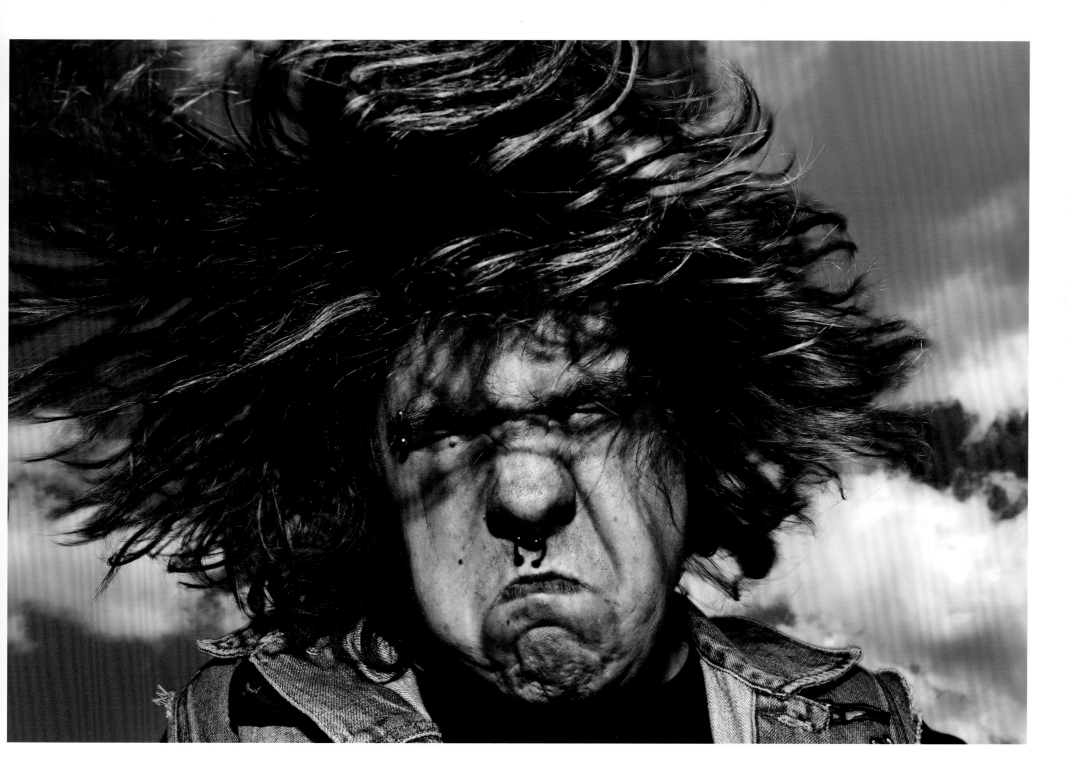

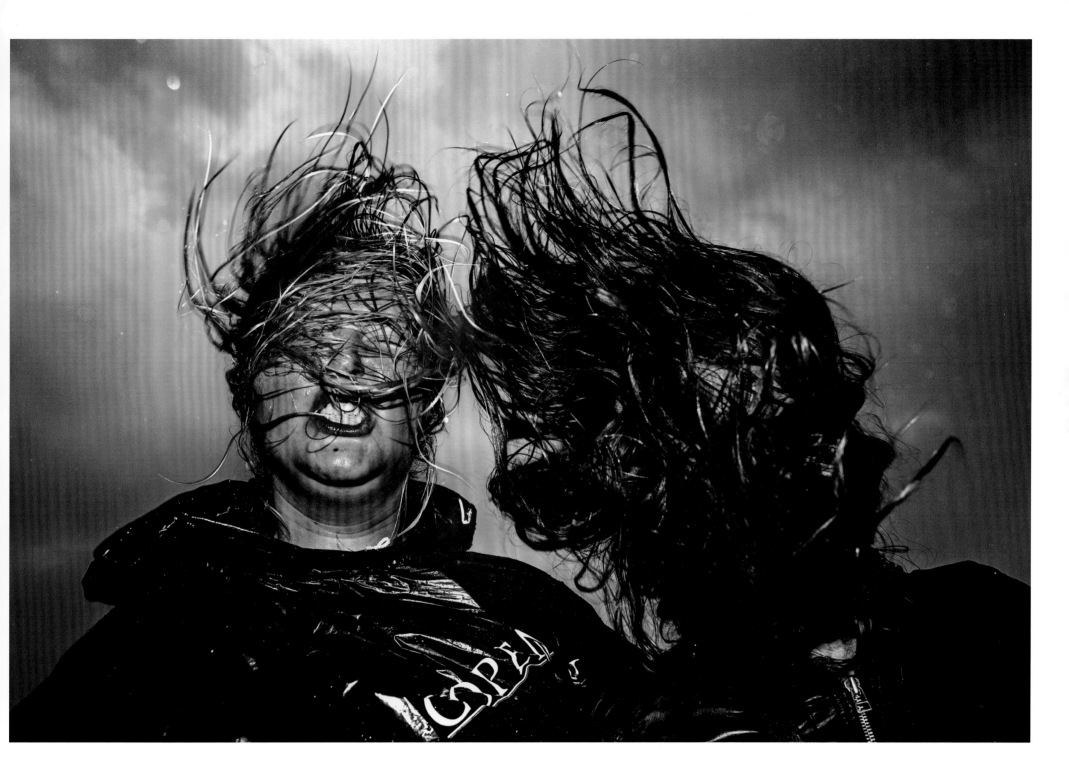

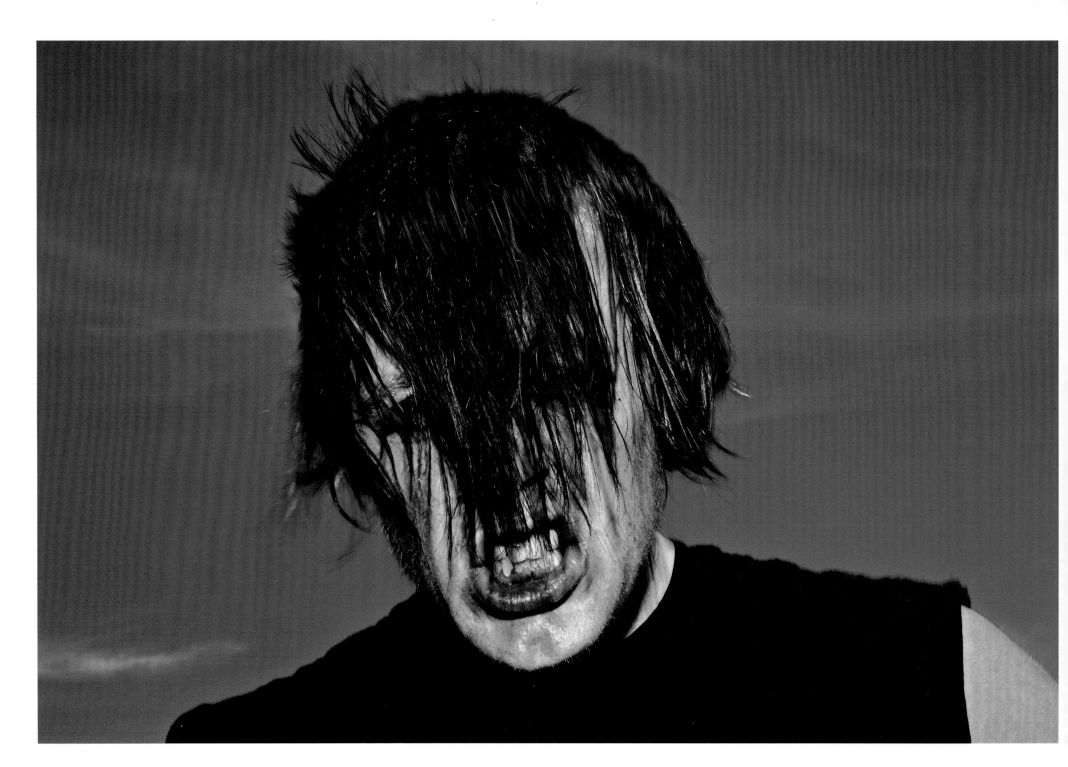

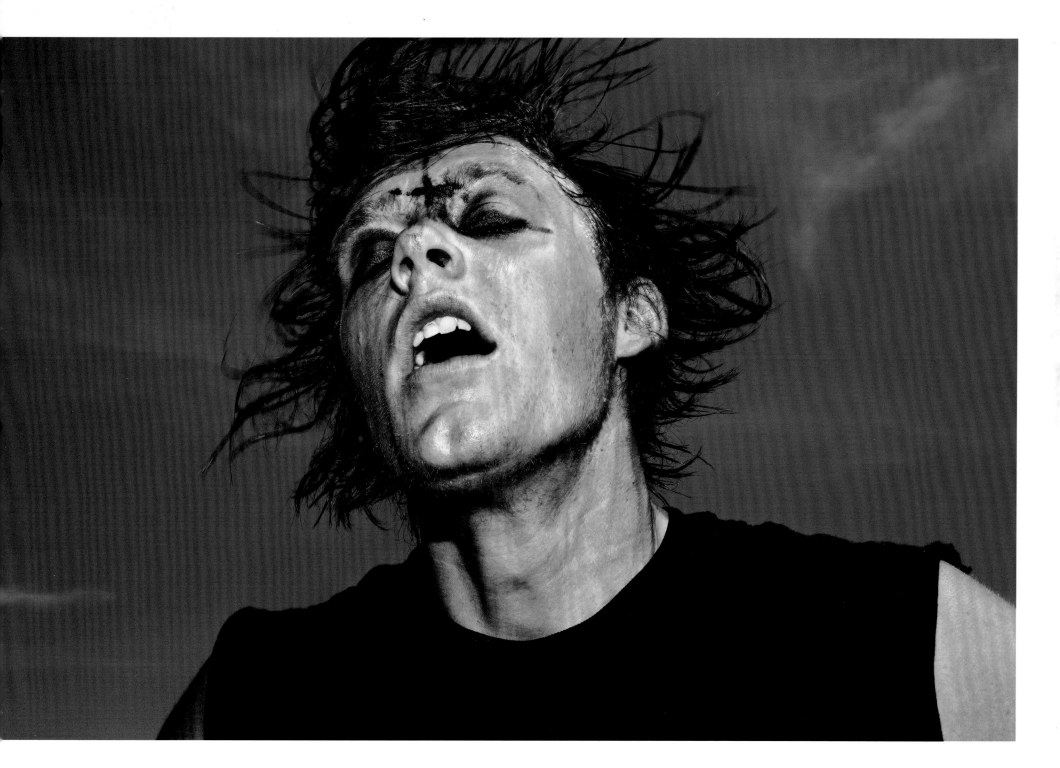

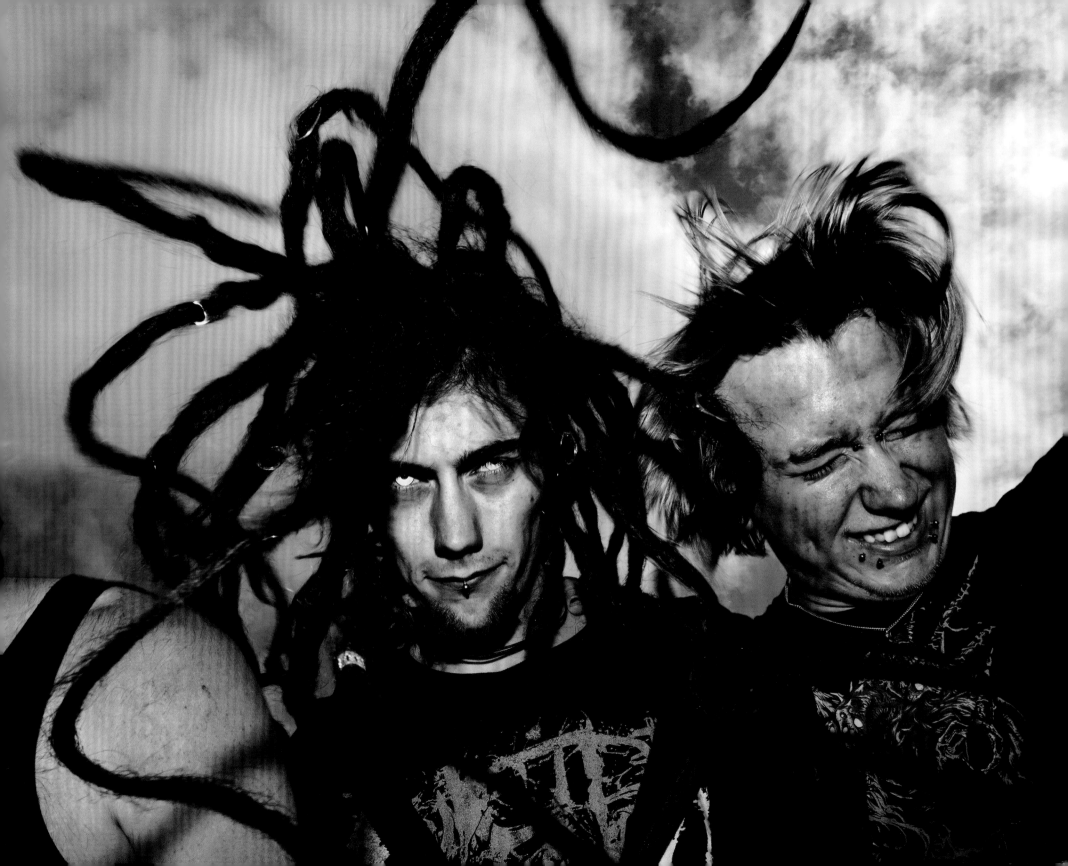

THANK YOU

Copenhell, Wacken Open Air, and Metaltown.

All the headbangers who accepted me jamming my camera right up in their faces.

My lovely wife Louise and my children Anna and Gustav Ehrbahn who have infinite patience and give me space to pursue my dreams and ambitions.

Per Folkver, who wrote the Foreword for this book and alas is no longer with us. He was my mentor and friend. No one has inspired me more than he did.

Thomas Borberg, my boss at Politiken, who has been supportive of this project from the start.

Rune Pedersen for helping me get the photos ready for printing.

Henriette Lind and Philip von Platen, who are always ready to throw a keen glance at my texts and translate them into English.

Liv Ajse for a first draft of the book's design.

To all my colleagues at Politiken for being who you are. You are all remarkable and inspiring company.

Kristine Kern and the staff at Fotografisk Center in Copenhagen for giving me a solo exhibition of *Headbangers*.

Sarah Giersing at The Royal Library - National Museum of Photography in Copenhagen for buying ten works from my exhibition *Headbangers*.

powerHouse Books/Craig Cohen, Wes Del Val, and Daniel Power for believing in this book.
Krzysztof Poluchowicz for the final design of the book and for respecting all my wishes.

Politiken Fonden for financial support.

Canon Denmark for being there when I need them.

Jacob Ehrbahn (1970) is a Danish photojournalist who has been a staff photographer at the Danish daily national newspaper *Politiken* since 2003. Prior to that, he worked for *Jyllands-Posten*, another Danish national newspaper, for six years.

Photo © Jens Panduro

Through the years, Ehrbahn has covered prominent news stories as well as the daily lives of people throughout the world. Notable among these are a project about Mongolian children living on the streets and below ground in the tunnels of the district heating system of Ulan Bator, the tsunami in Sri Lanka, an earthquake in Kashmir, flooding in Pakistan, U.S. presidential elections, the Egyptian revolution in Cairo's Tahrir Square, Nelson Mandela's funeral, and the 2014 uprising in Kiev's Independence Square.

He has received numerous awards for his work, including being named second and third place "Newspaper Photographer of the Year" by POYi in 2003 and 2011. He's a two-time World Press Photo winner with second and third-place prizes in 2004 and 2013. In 2015 he was named Photographer of the Year in Denmark for the third time.

In December 2008 he had his first photobook *69: Kampen for et ungdomshus,* published in Denmark. For 17 months Ehrbahn followed young activists' struggle to establish a new alternative youth house in Copenhagen, after their former house was demolished by the authorities and riots broke out.

Jacob Ehrbahn lives in Espergaerde outside Copenhagen, Denmark with his wife Louise and their children Anna and Gustav. From time to time, Jacob delves into labors of love on the side, away from his full-time job. *Headbangers* is one of these projects.

Per Folkver (1953 – 2014) was for many years the Photo Editor-in-Chief at *Politiken* and a three-time member of the jury at World Press Photo. He published several books of his own photos, was a teacher and lecturer, as well as an invaluable source of inspiration for a whole generation of young Danish photographers.

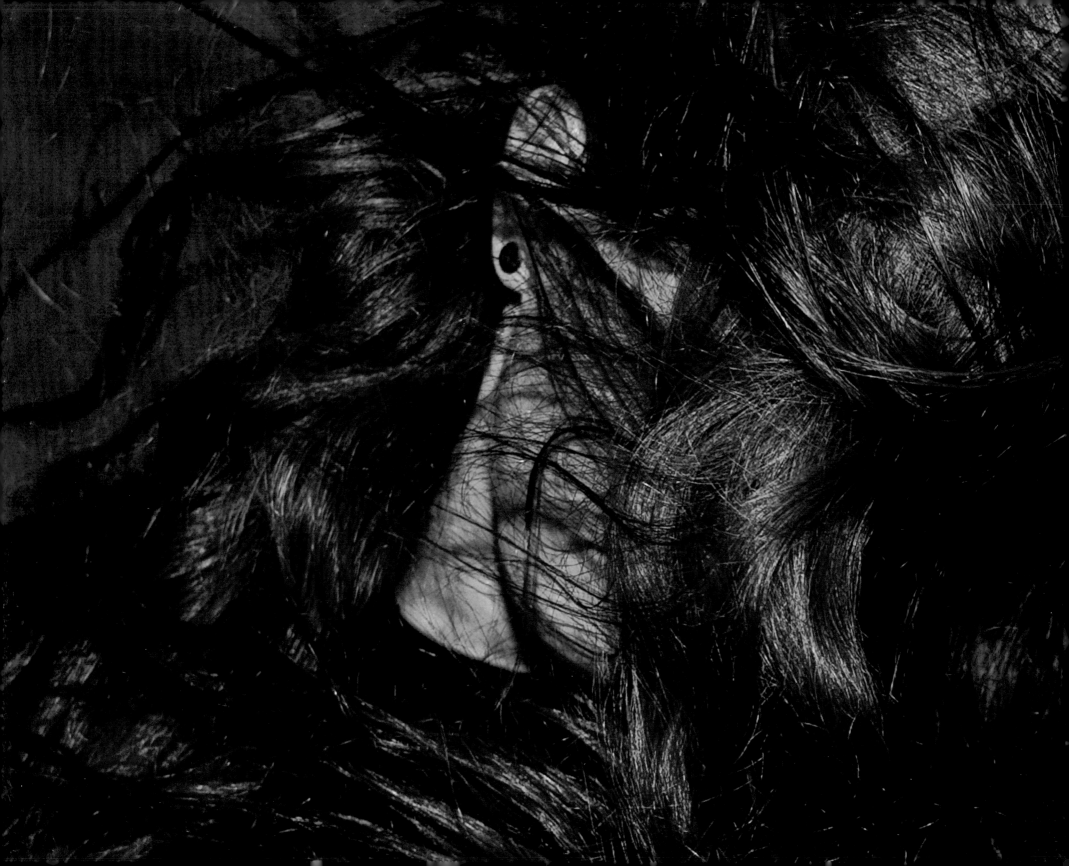

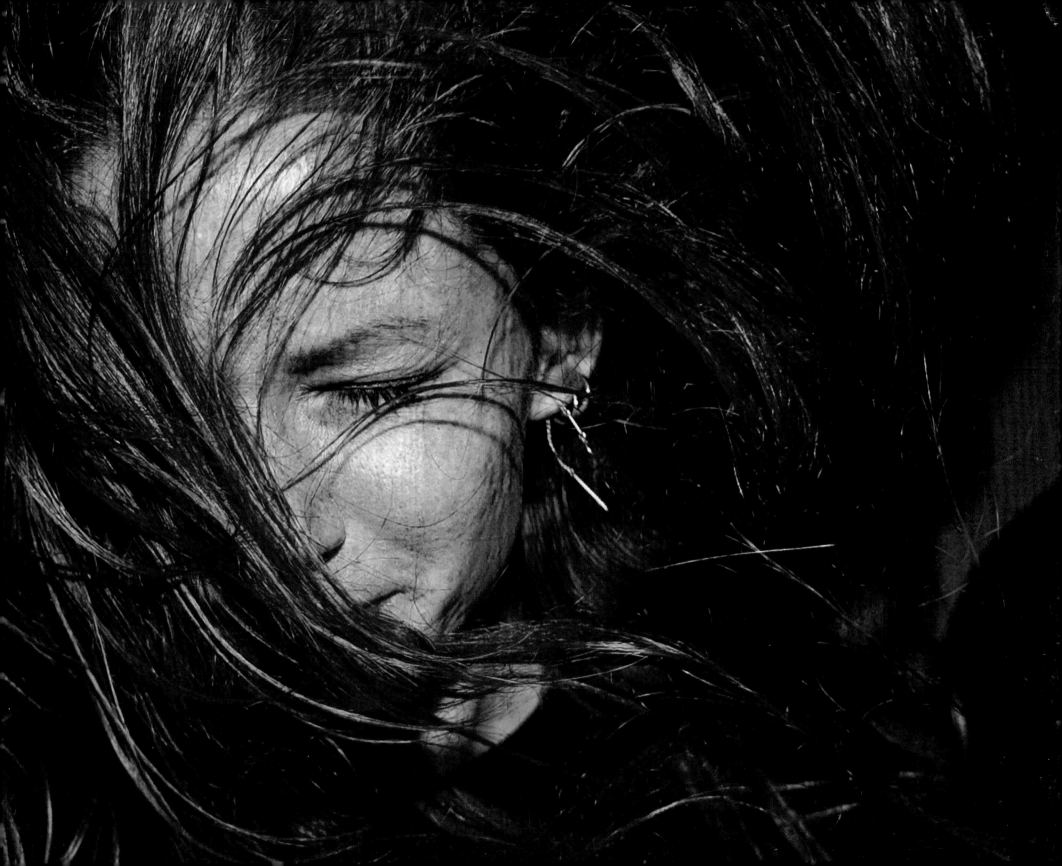

Headbangers

Photographs © 2015 Jacob Ehrbahn
Foreword © 2015 Per Folkver

Published in the United States by powerHouse Books,
a division of powerHouse Cultural Entertainment, Inc.
37 Main Street, Brooklyn, NY 11201-1021
telephone 212.604.9074, fax 212.366.5247
e-mail: info@powerHouseBooks.com
website: www.powerHouseBooks.com

First edition, 2015

Library of Congress Control Number: 2015942194

Hardcover ISBN 978-1-57687-764-7

Printed by Asia Pacific Offset

Book design by Krzysztof Poluchowicz

10 9 8 7 6 5 4 3 2 1

Printed and bound in China